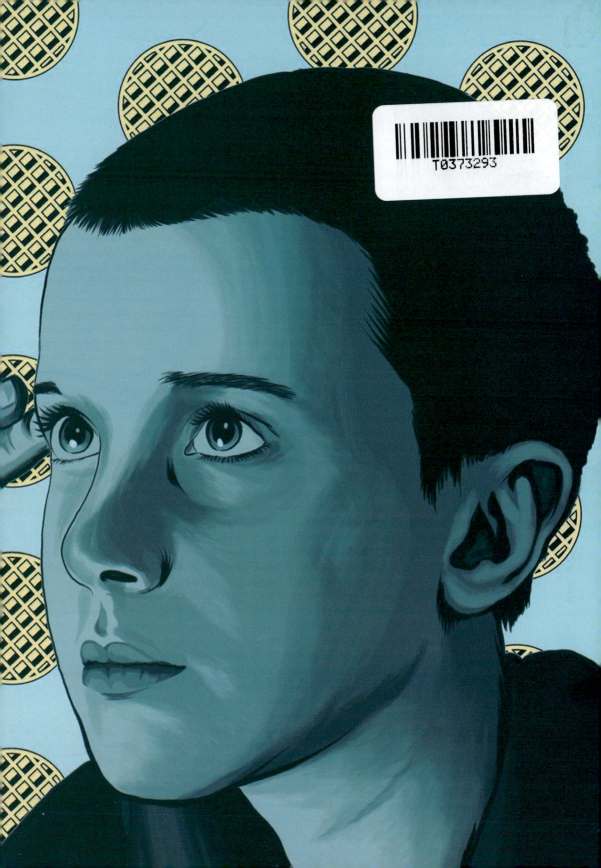

© 2022 Monsa Publications

First edition in 2022 December by Monsa Publications,
Gravina 43 (08930) Sant Adrià de Besós. Barcelona (Spain)
T +34 93 381 00 50
www.monsa.com monsa@monsa.com

Project director Anna Minguet.
Author and art director & layout Eva Minguet.
(Monsa Publications)
Stranger Things is a Netflix original series, created by
The Duffer Brothers. This is a Fanart tribute book to the
Stranger Things series, and is not authorized or promoted
by any person or entity owner of the copyright.
©The images belong to the authors.

Cover image by Cristina Franco Roda
@MENGANITAdecual
Back cover image by Joseph Shelton
@artofjosephshelton

Printed in Spain.
Translation by SomosTraductores.

Shop online:
www.monsashop.com

Follow us!
Instagram @monsapublications
Facebook @monsashop

ISBN: 978-84-17557-60-7
D.L. B 19688-2022

STRANGER THINGS
1983 TRIBUTE 1986

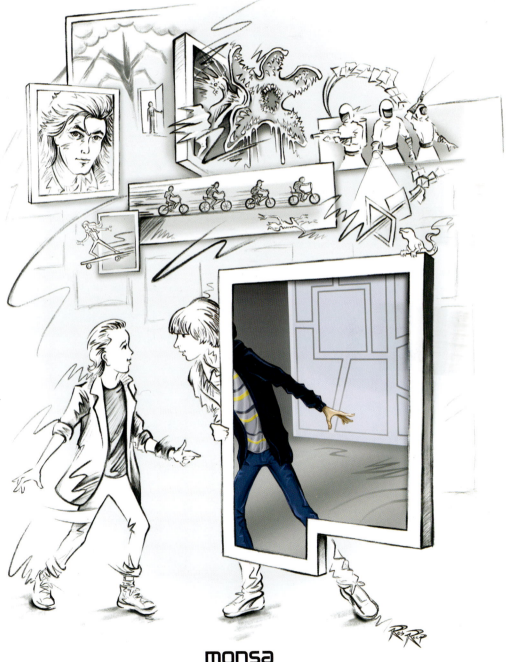

monsa

Stranger Things is characterised by having the heart and essence of the mythical series and films of the 80's, from The Goonies, Ghostbusters, Back to the Future, The Neverending Story, Indiana Jones, Alien, The Thing, The Howling, Poltergeist, E.T., Stand by Me, Firestarter, A Nightmare on Elm Street, Jaws and so many more, which were authentic icons for that generation. The series has the same breath of fresh air as the past that it wants to reflect, since the first episode it has managed to captivate our hearts, telling us the story of four friends from a town called Hawkins, who deal with the disappearance of one of them, Will. While the mysteries link together, a new character, Eleven, appears who will bring a new vision of what happened. During all its seasons the characters have not stopped evolving, letting us always see different gestures that will transport us directly to the past. From its aesthetics, music on tape cassettes, arcades, the first malls... A brilliant series that explores the crossroads between the ordinary and the extraordinary.

Stranger Things se caracteriza por tener todo el corazón y la esencia de las míticas series y películas de los años 80, desde The Goonies, Ghostbusters, Back to the Future, The Neverending Story, Indiana Jones, Alien, The Thing, The Howling, Poltergeist, E.T., Stand by Me, Firestarter, A Nightmare on Elm Street, Jaws y muchas más, que fueron todo un icono para los que vivieron aquella generación. La serie respira la misma frescura de ese pasado que quiere reflejar, desde el primer capítulo ha conseguido cautivar nuestros corazones, contándonos la historia de cuatro amigos de un pueblo llamado Hawkins, que se enfrentan a la desaparición de uno de ellos, Will. Mientras los misterios se encadenan uno con otro, aparece un nuevo personaje, Once, que aportará una nueva visión de lo sucedido. Durante todas sus temporadas, los personajes no han dejado de evolucionar, dejándonos ver siempre diferentes guiños que nos transportarán directamente al pasado. Desde su estética, música en formato cassette, salones de máquinas recreativas, los primeros centros comerciales... Una gran serie que explora la encrucijada donde lo ordinario se encuentra con lo extraordinario.

The Duffer Brothers

Stranger Things was created by Matt and Ross Duffer, known as the Duffer Brothers. Twin brothers, writers and film and television directors, mentored by Shyamalan and fans of Steven Spielberg, John Carpenter, Stephen King and George Lucas, among other authors and directors.

The Duffer Brothers wrote a script and showed the story to fifteen networks who all rejected it, saying that the argument centred on children as the main characters would not work, and advised them to turn it into a youth series or focus on Hopper's research on the paranormal.

But the producers Cohen and Levy read the script and contacted the Duffer Brothers, shortly after Netflix bought the entire season and it premiered in 2016 with excellent reviews, especially for its characterisation, pace, atmosphere, acting, soundtrack, direction and tributes to the films and the western culture of the '80s.

For deciding the title and font of the series, the Duffer brothers were inspired by a Stephen King novel, Needful Things. Once's role is similar to the character played by Drew Barrymore in the movie Firestarter, also King's novel.

Stranger Things fue creada por Matt y Ross Duffer, conocidos como los hermanos Duffer. Hermanos mellizos, escritores y directores de cine y televisión, instruidos por Shyamalan y amantes de las obras de Steven Spielberg, John Carpenter, Stephen King y George Lucas, entre otros autores y directores.

Los hermanos Duffer prepararon un guión y enseñaron la historia a unas quince cadenas, todas lo rechazaron, diciendo que el argumento centrado en los niños como personajes principales no funciona, y les aconsejaron que lo convirtieran en una serie juvenil o se centraran en la investigación de Hopper en lo paranormal.

Pero los productores Cohen y Levy, leyeron el guión y contactaron con los hermanos Duffer, poco después Netflix compró toda la temporada y se estrenó en 2016 con excelentes críticas, especialmente por su caracterización, ritmo, atmósfera, actuación, banda sonora, dirección y los homenajes a las películas y a la cultura occidental de los años 80.

Para el título y fuente de la serie, los hermanos Duffer se inspiraron en una novela de Stephen King, Needful Things. El papel de Once es similar al personaje interpretado por Drew Barrymore en la película Firestarter, también novela de King.

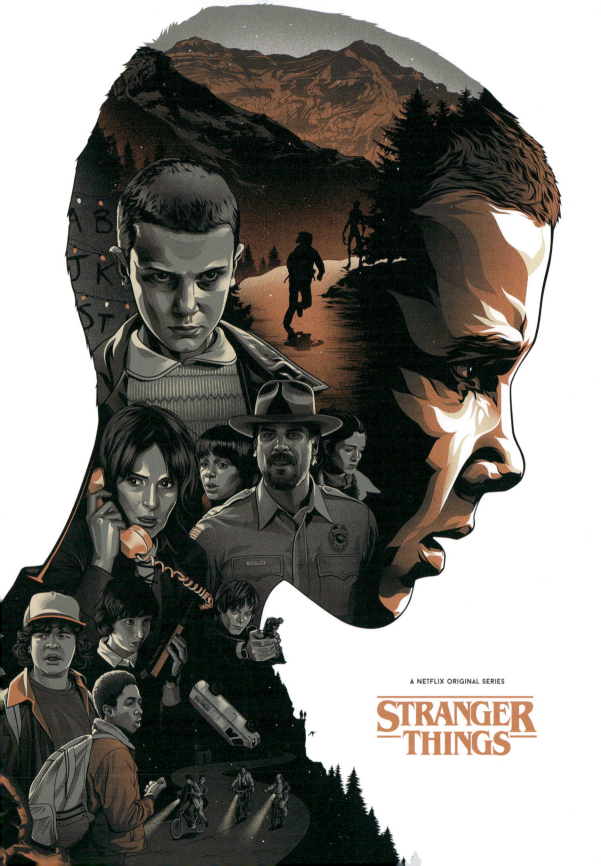

A NETFLIX ORIGINAL SERIES

STRANGER THINGS

Chapters: The Vanishing of Will Byers. The Weirdo on Maple Street. Holly, Jolly. The Body. The Flea and the Acrobat. The Monster. The Bathtub. The Upside Down.

It all starts on 6 November 1983, in the fictional town of Hawkins, Indiana. Will Byers, a 12-year-old boy, after spending hours playing Dungeons and Dragons with his friends, Mike Wheeler, Dustin Henderson and Lucas Sinclair, mysteriously disappears on his way home. His mother, Joyce, and police chief Jim Hopper, begin to search for him desperately. At the same time, a young woman with psycho-kinetic powers called Eleven meets Will's friends and will be key to finding him. None of them imagine the sinister forces they will have to face.

Todo empieza el 6 de Noviembre de 1983, en el pueblo ficticio de Hawkins, Indiana. Will Byers, un niño de 12 años de edad, tras pasar horas jugando a Dungeons and Dragons con sus amigos, Mike Wheeler, Dustin Henderson y Lucas Sinclair, desaparece misteriosamente al regresar a casa. Su madre, Joyce, y el jefe de policía Jim Hopper, empiezan su búsqueda desesperadamente. Al mismo tiempo, una joven con poderes psicoquinéticos llamada Once, conoce a los amigos de Will y será clave para poder encontrarlo. Ninguno de ellos se imagina las siniestras fuerzas con las que tendrán que enfrentarse.

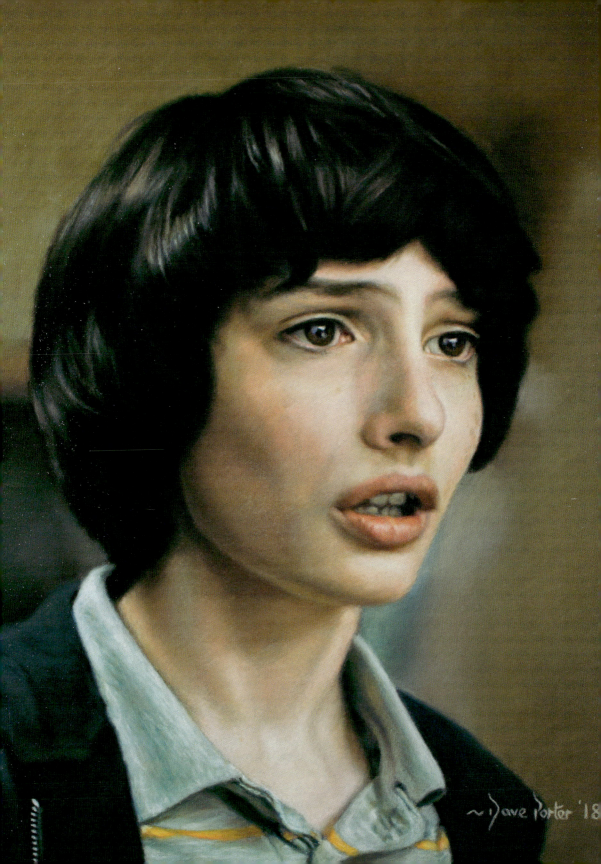

~Dave Porter '18

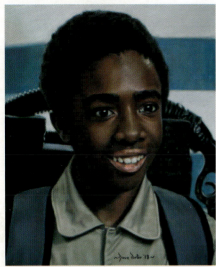

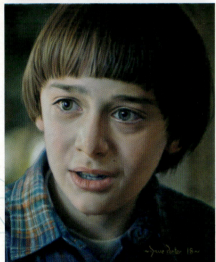

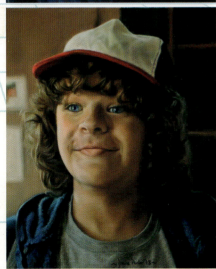

Dungeons & Dragons

It is a fantasy role-playing game, and the favourite game of the 4 youngsters. Mike "Dungeon Master", Lucas "The Knight", Will "The Wise" and Dustin "The Dwarf".

Es un juego de rol de fantasía, y el juego preferido de los 4 jovenes. Mike "Maestro del Calabozo", Lucas "El Caballero", Will "El Sabio" y Dustin "El Enano".

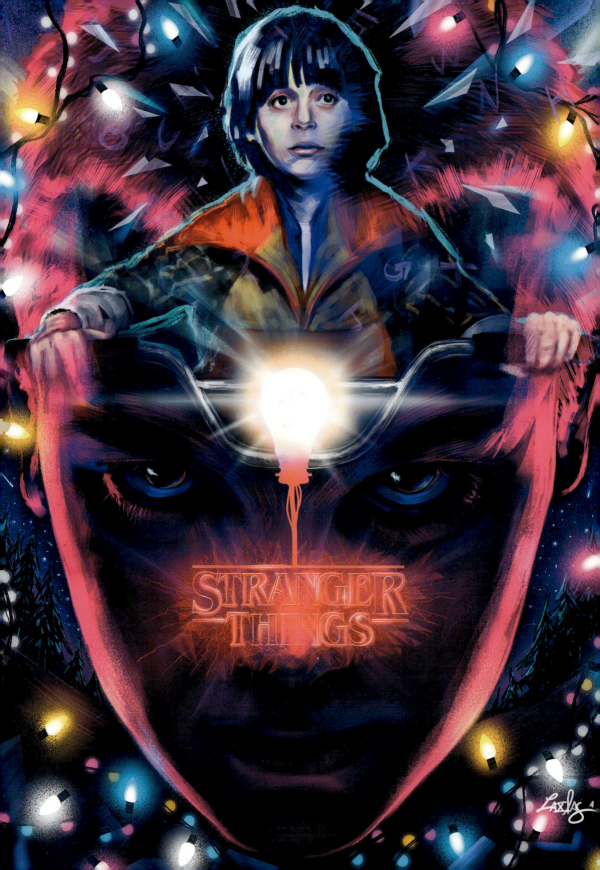

"THE ROLL, IT WAS A SEVEN.
THE DEMOGORGON
IT GOT ME.
SEE YOU TOMORROW"

"Me había salido un siete.
El Demogorgon me ha pillado. Hasta mañana"

- Will Byers -

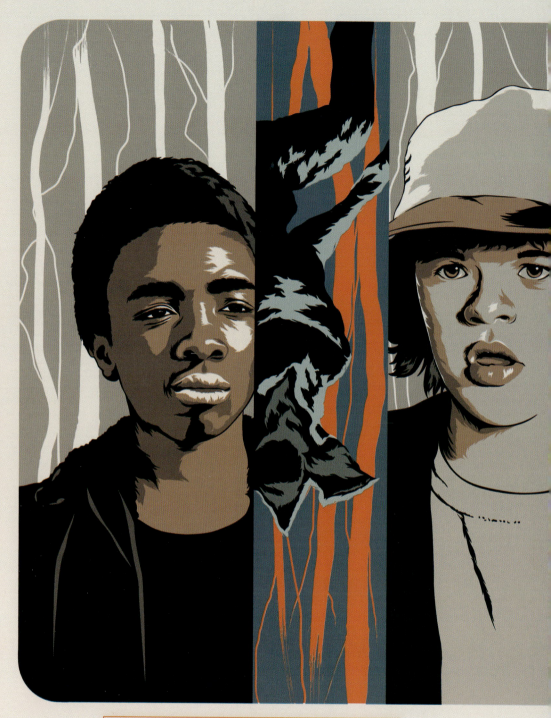

STRANGER
THINGS

WINON.
CALEB MC

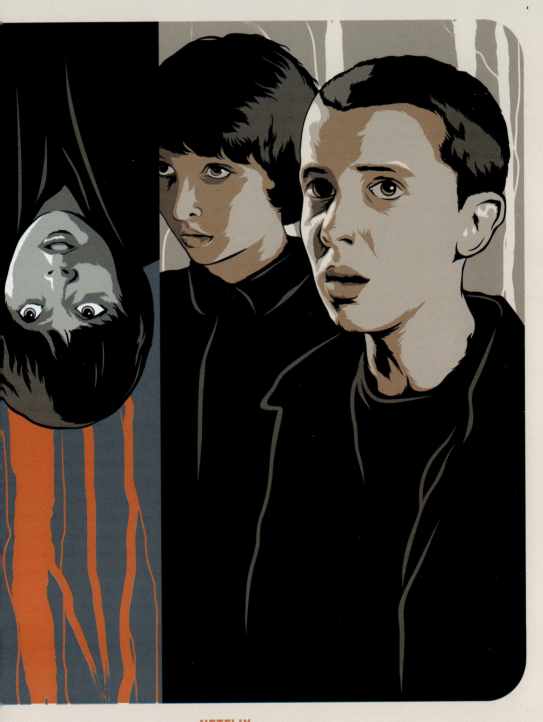

21 LAPS ENTERTAINMENT PRESENTS A **NETFLIX** ORIGINAL SERIES

CREATED BY THE DUFFER BROTHERS
ER | DAVID HARBOUR | FINN WOLFHARD | MILLIE BOBBY BROWN | GATEN MATARAZZO
LIN | CHARLIE HEATON | CARA BUONO | MATTHEW MODINE | JOE KEERY | NATALIA DYER
MUSIC BY KYLE DIXON & MICHAEL STEIN

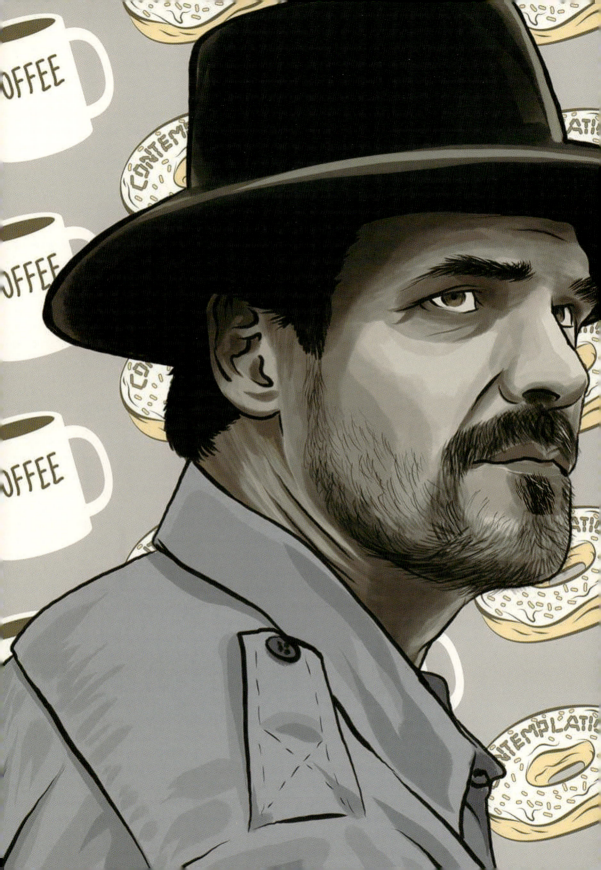

"MORNINGS ARE FOR COFFEE AND CONTEMPLATION"

"Las mañanas son para el café y la contemplación"

- Jim Hopper -

Jim Hopper is the police chief of the town of Hawkins and is in charge of investigating Will Byers' disappearance. The most charismatic characters in the series hides behind a rough and dishevelled appearance. Bold and nonconformist, he never gives up looking for Will.

Jim Hopper es el jefe de policía de la ciudad de Hawkins, y el encargado de dirigir la investigación de la desaparición de Will Byers. Bajo su aspecto rudo y desaliñado, se esconde uno de los personajes más carismáticos de la serie. Audaz e inconformista, no se da nunca por vencido en la búsqueda de Will.

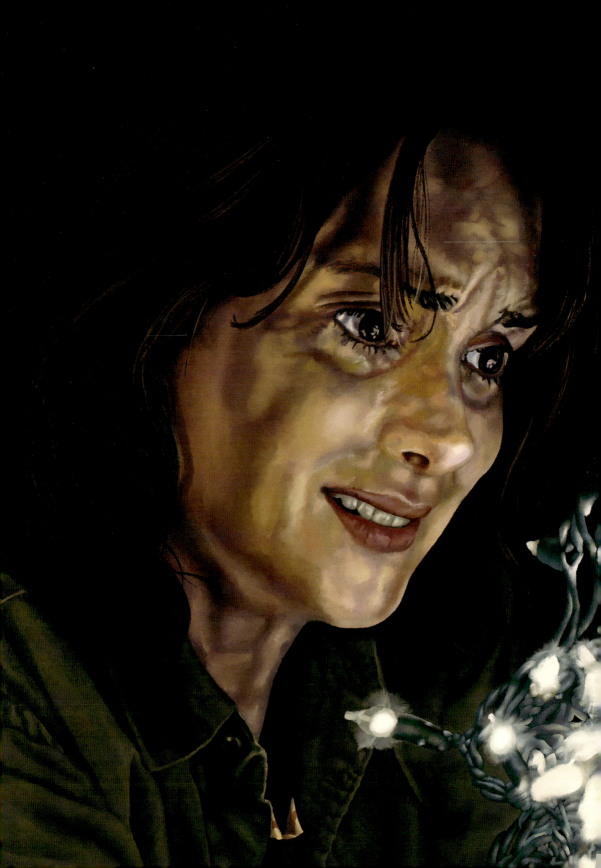

Joyce Byers

She is one of the protagonists of the series, she a single mother and works in a Hawkins store. One morning before leaving home, she sees that her youngest son Will is missing, she and her eldest son Jonathan worry after discovering that he has not slept at home, and after some phone calls to his friends, decides to go to report the disappearance to the police. Joyce, as the mother courage she is, never ceases to look for Will, trusting at all times that she will find him, despite the crises and mistrust that arise around her.

Es una de las protagonistas de la serie, es madre soltera y trabaja en un comercio de Hawkins. Una mañana antes de salir de casa, se da cuenta de la falta de su hijo menor Will, ella y su hijo mayor Jonathan se preocupan tras descubrir que no ha dormido en casa, y tras unas llamadas de teléfono a sus amigos, decide ir a denunciar la desaparición a la policia. Joyce, como madre corage que es, no cesa jamás en la busqueda de Will, confiando en todo momento en que le encontrará, pese a las crisis y desconfianzas que surgen a su alrededor.

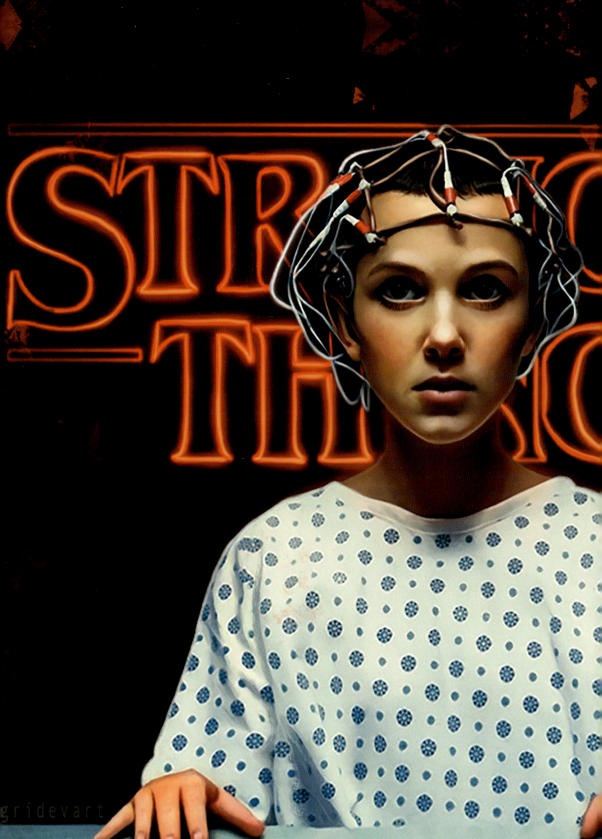

Subject 011

Eleven is a girl who was experimented on to exploit her telekinetic powers to use them for secret purposes, all under the control of Dr. Brenner.

Once es una niña que fue objeto de diversos experimentos cuyo objetivo era explotar sus habilidades telequinéticas y así poder usarlas para fines secretos, todo bajo el control del doctor Brenner.

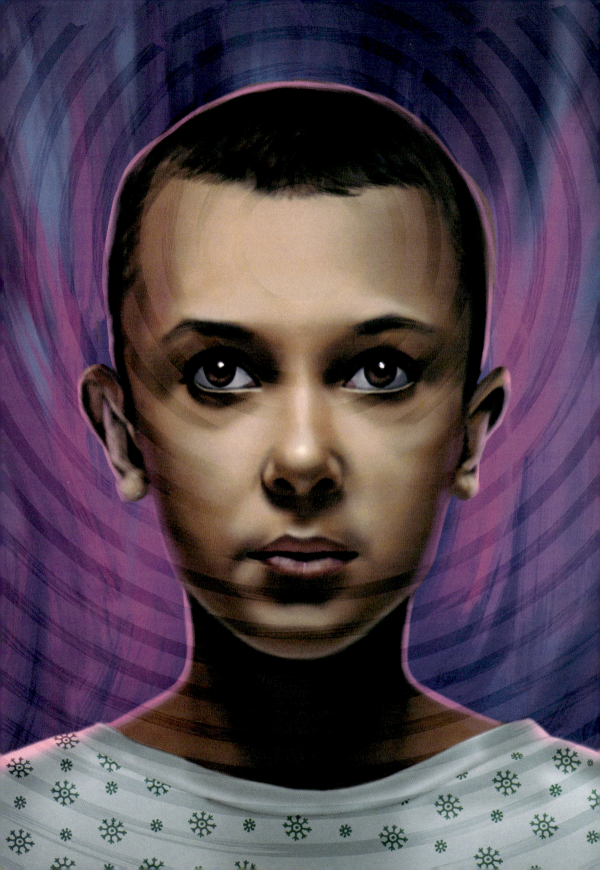

Hawkins National
—Laboratory—

Dr. Martin Brenner

Dr. Martin Brenner is a scientist and director of the Hawkins National Laboratory. He is in charge of working with different individuals to develop their psychic abilities. Brenner raised Jane under the name of Eleven and she referred to him as her "Papa". One of Eleven's skills was looking for people, Brenner used her as a spy on Russian agents for his benefit.

While conducting a search, Eleven ran into a monstrous creature, Brenner forced Eleven to establish contact, which would lead to horrible consequences.

El Dr. Martin Brenner es científico y director del Laboratorio Nacional de Hawkins. Es el encargado de trabajar con diferentes sujetos para desarrollar sus capacidades psíquicas. Brenner crió a Jane bajo el nombre de Once y esta se refería a él como su "Papá". Una de las habilidades de Once era la búsqueda de personas, Brenner la usó como espía de agentes rusos para su beneficio.

Mientras realizaba una búsqueda, Once se topó con una criatura monstruosa, Brenner obligó a Once a establecer contacto, lo que traería consecuencias horribles.

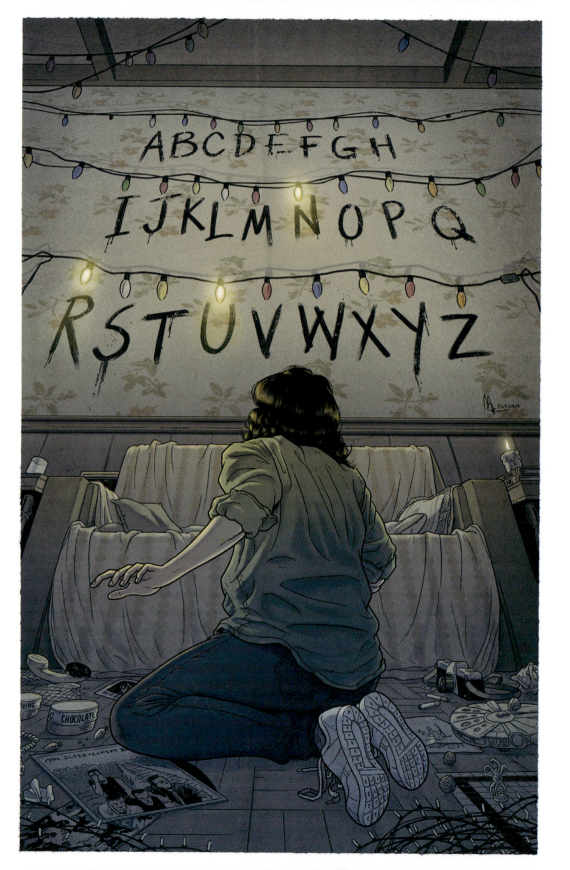

"I DON'T CARE IF ANYONE BELIEVES ME!"

"¡No me importa si nadie me cree!"

- Joyce Byers -

Joyce creates an alphabet with Christmas lights to communicate with her son Will. This alphabet became the icon of the series. Thanks to the imagination of a mother who does not lose hope at any time, we see how she manages to communicate and be able to find a way of knowing that she is still alive.

Joyce crea un alfabeto con luces de Navidad para comunicarse con su hijo Will. Este alfabeto se convirtió en el icono de la serie. Gracias a la imaginación de una madre que no pierde la esperanza en ningún momento, vemos como consigue comunicarse y poder encontrar la forma de saber que sigue con vida.

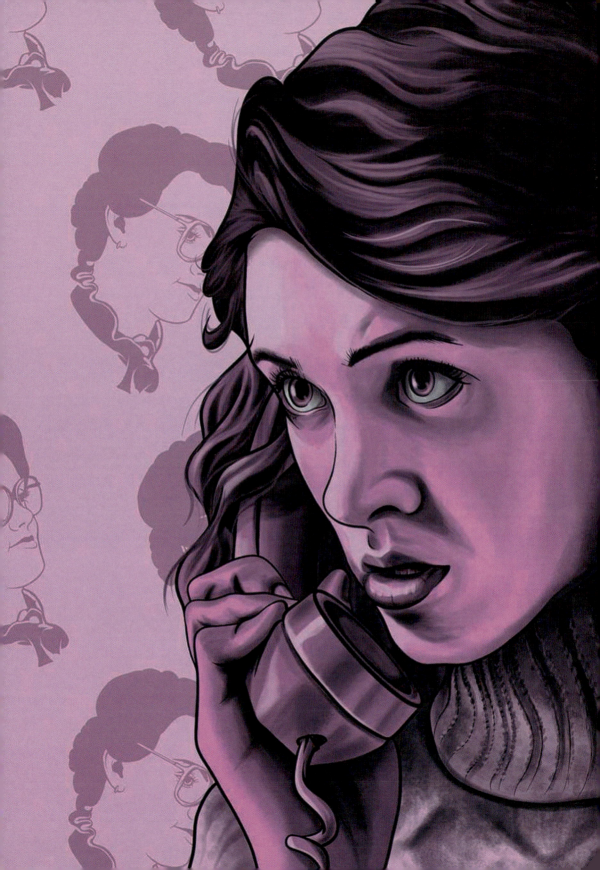

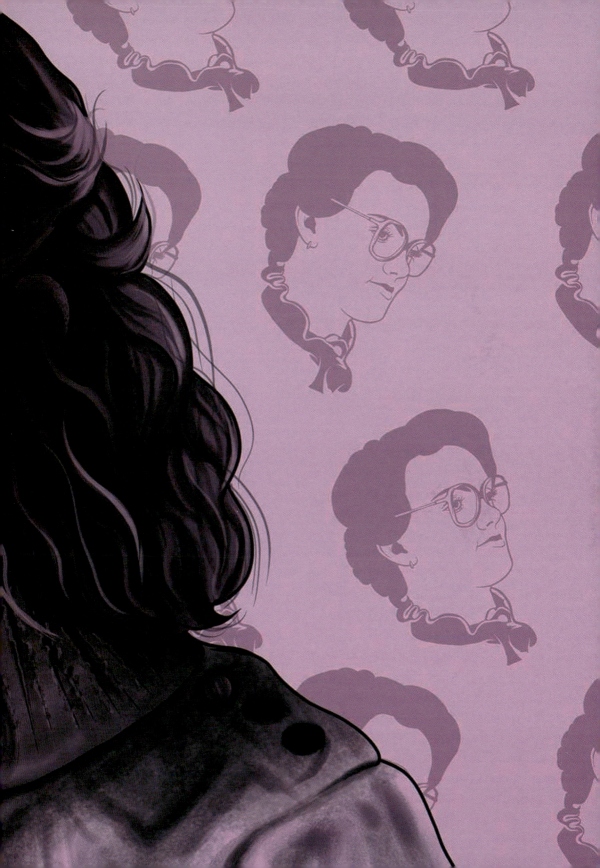

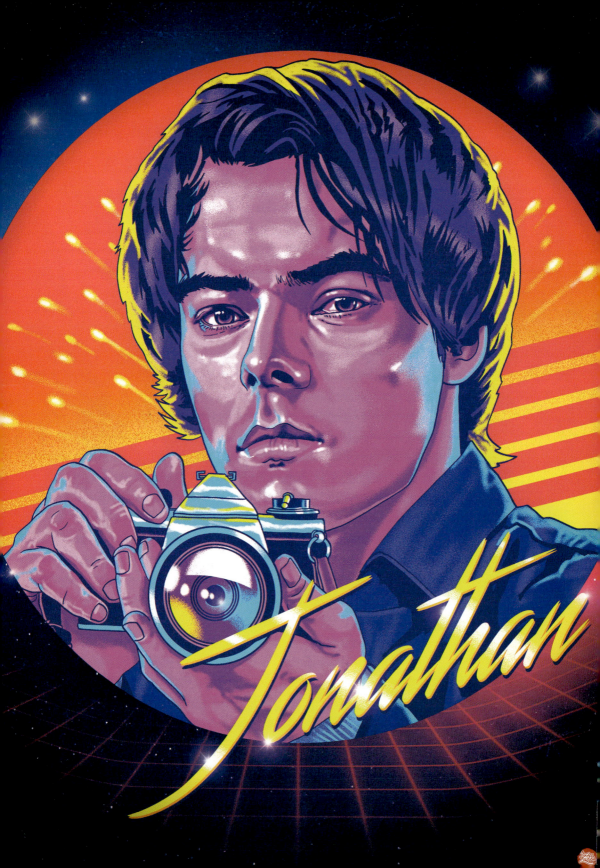

"IT'S JUST, SOMETIMES PEOPLE
DON'T REALLY SAY
WHAT THEY'RE REALLY THINKING.
BUT WHEN YOU CAPTURE THE RIGHT MOMENT...
IT SAYS MORE"

"A veces, las personas no te dicen lo que piensan en realidad. Pero si captas el momento adecuado, descubres más"

- Jonathan Byers -

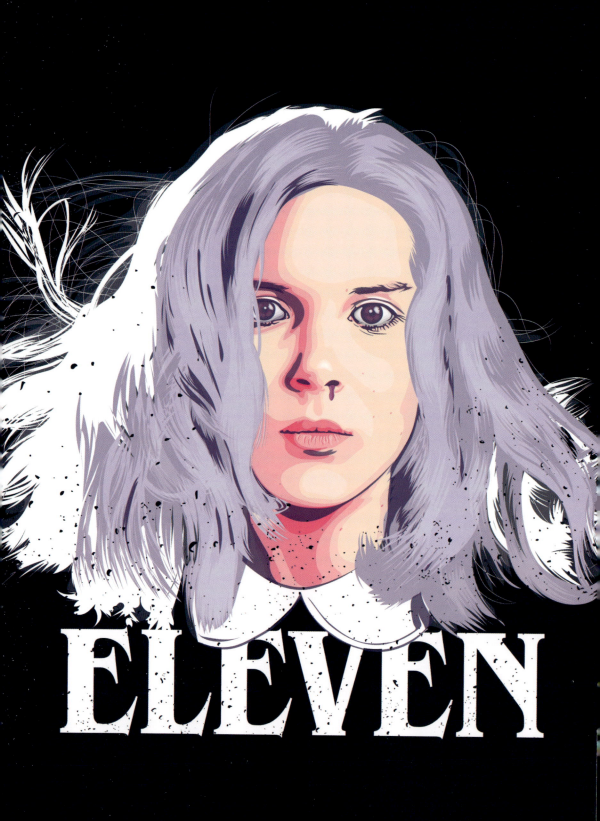

ELEVEN

"FRIENDS DON'T LIE"

"Los amigos nunca mienten"

- Eleven -

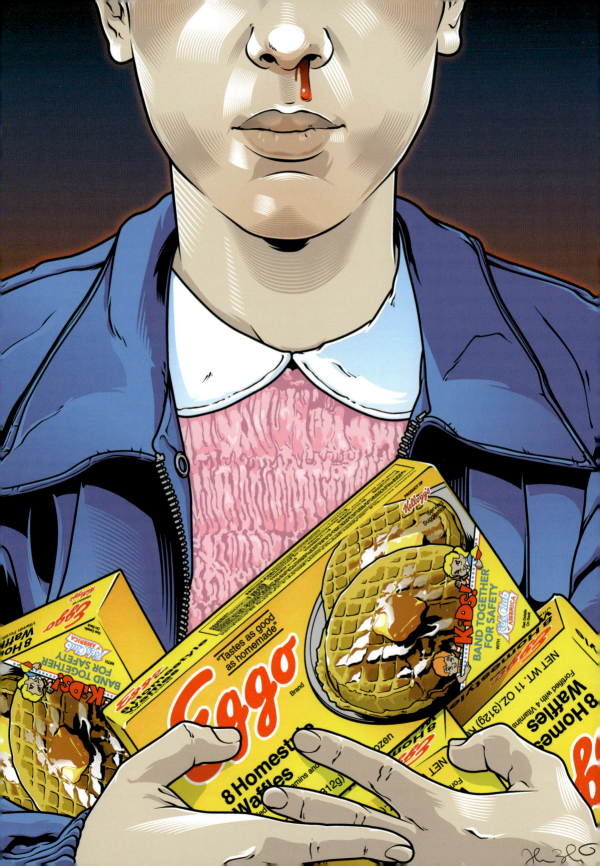

"SHE'S OUR FRIEND AND SHE'S CRAZY!"

"¡Ella es nuestra amiga y está loca! "

- Dustin Henderson -

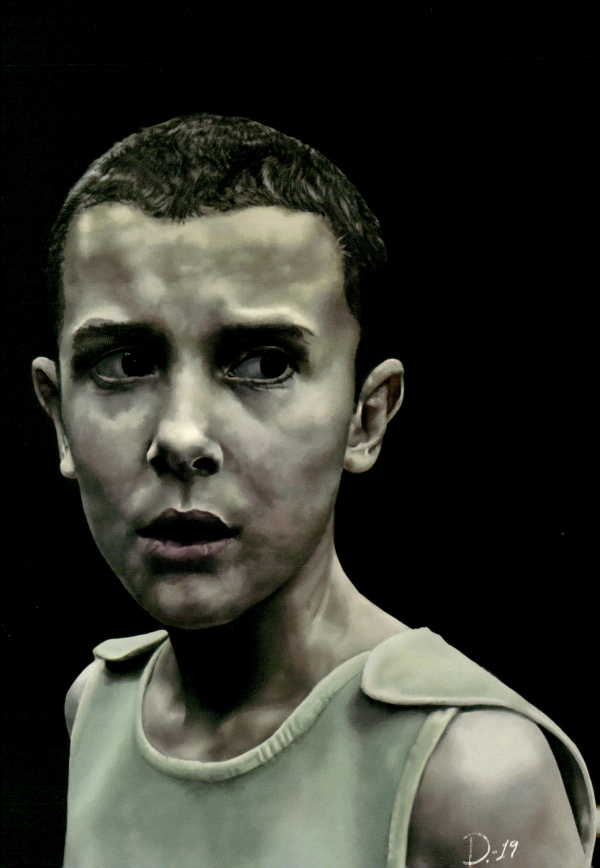

Demogorgon

Nothing is known about the origin of Demogorgon or its home, but it was discovered by a girl with special talents called "Eleven". During her encounter with the Demogorgon, Eleven touches him, and the creature uses his contact with her to build a "Door" to our reality and is freed into our world, where he enters to hunt animals and people.

No se sabe nada sobre los orígenes de Demogorgon o su hogar, pero fue descubierto por una niña con dones especiales llamada "Once". Durante su encuentro con el Demogorgon, Once lo toca, y la criatura usa su contacto con él, para construir una "Puerta" a nuestra realidad, quedando libre en nuestro mundo, donde entra para cazar animales y personas.

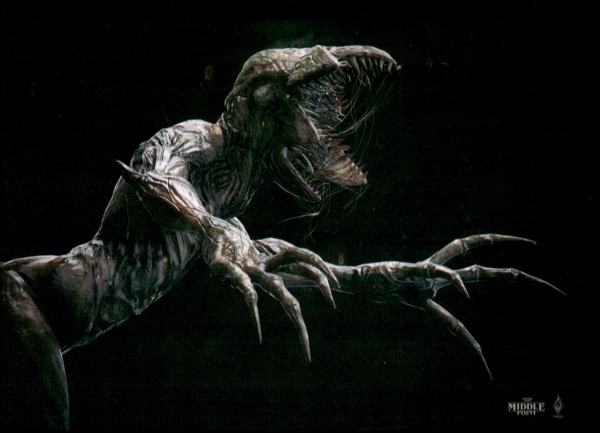

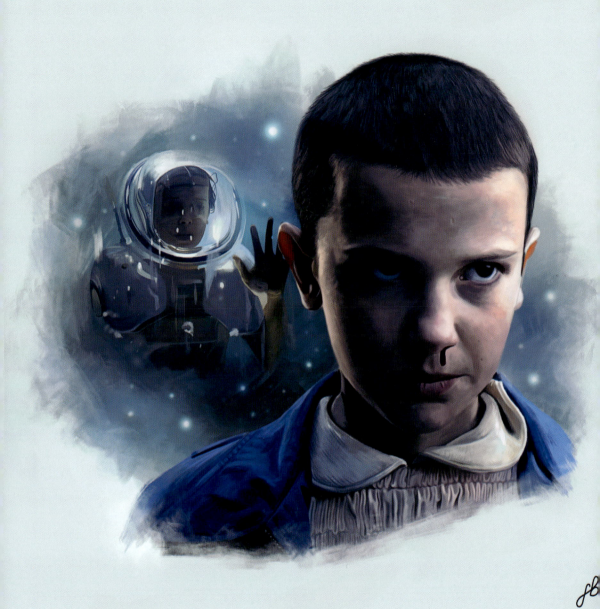

Sychokinetic Abilities - 011

Eleven developed special gifts, and every time she uses her powers, her body weakens.
• Telekinesis: She can move objects with her mind. Anger increases this power, and she can blow up a van.
• Biokinesis: Ability to control organic matter, can cause muscular paralysis or crush the brain of several people.
• Clairvoyance: Ability to find a person or object, with just one photograph.
• Alter the electromagnetic field.
• Voice projection: The ability to reproduce what a person says through a communication device.

Once desarrolló dones especiales, y cada vez que usa sus poderes, su cuerpo se debilita.
• Telequinesis: Puede mover objetos con la mente. La ira aumenta este poder, siendo capaz de hacer volar una furgoneta.
• Bioquinesis: Capacidad para controlar la materia orgánica, puede causar parálisis muscular, o aplastar el cerebro de varias personas.
• Clarividencia: Capacidad de encontrar a una persona u objeto, con tan solo una fotografía.
• Alterar el campo electromagnético.
• Proyección de voz: La habilidad de reproducir lo que dice una persona a través de un aparato de comunicación.

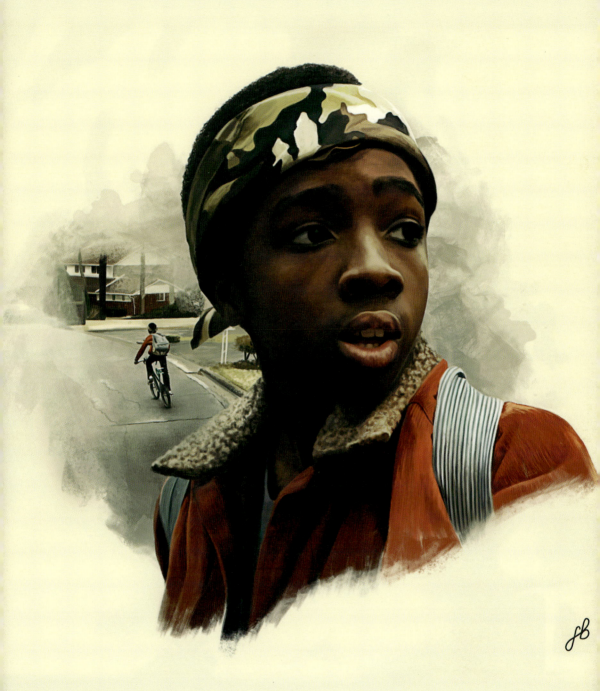

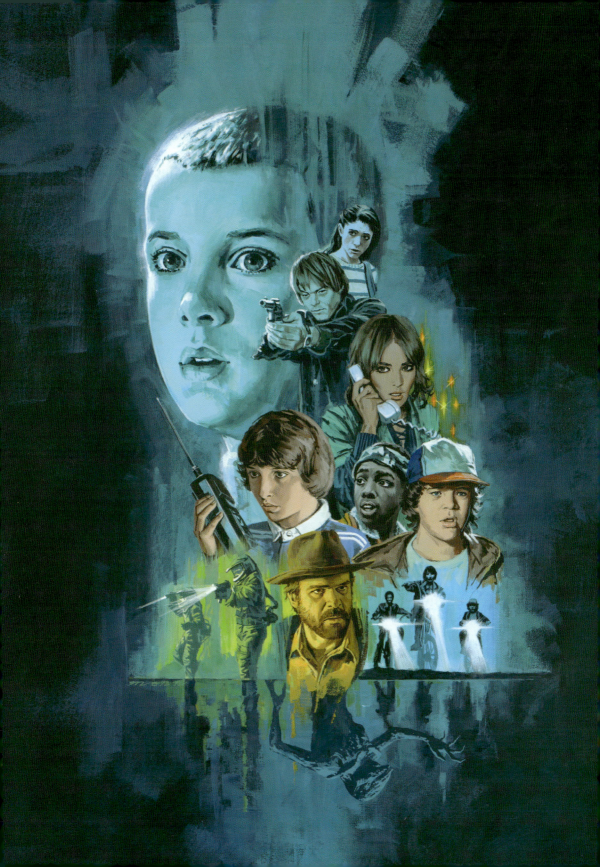

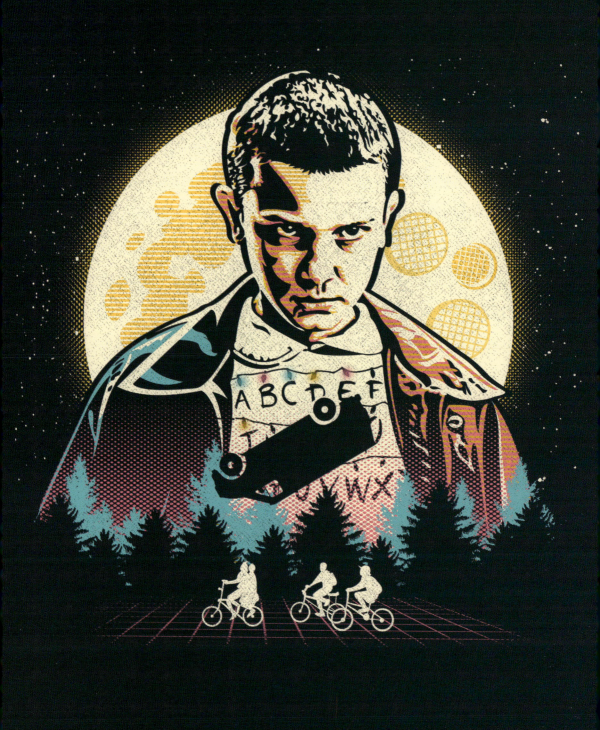

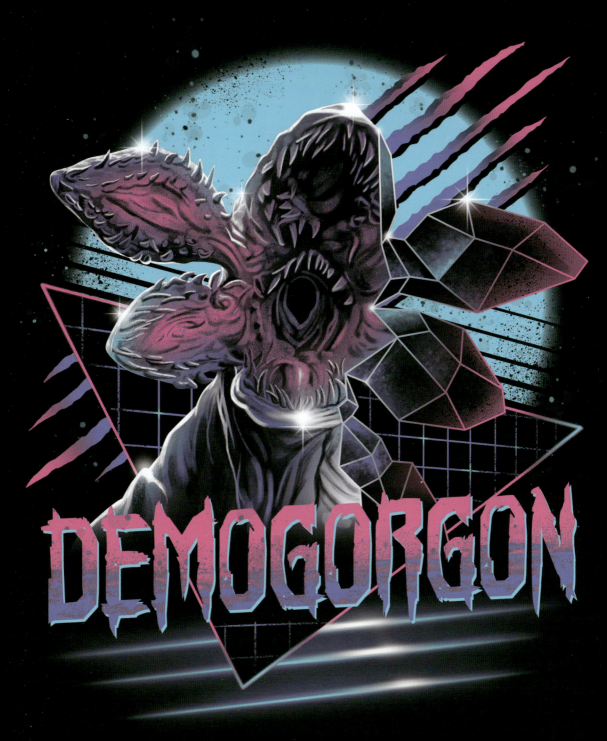

DEMOGORGON

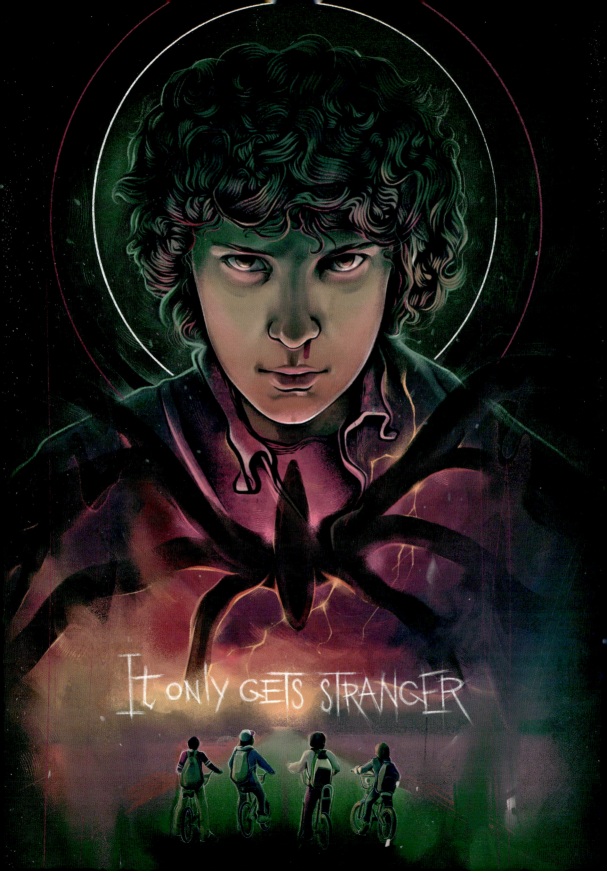

It only gets stranger

Chapters: MadMax. Trick or Treat, Freak. The Pollywog. Will the Wise. Dig Dug. The Spy. The Lost Sister. The Mind Flayer. The Gate.

One year later, in October 1984, and after Will's rescue, he, far from being able to return to normal, realises that he is trapped between the two worlds, and does not stop seeing something that frightens and threatens him with a terrible future for everyone in the town of Hawkins. Eleven, who survived her battle with the Demogorgon, is safe with Chief Jim Hopper, but the Upside Down world will strike terror again by spreading it throughout Hawkins.

Un año más tarde, en octubre de 1984, y tras el rescate de Will, éste lejos de poder volver a la normalidad, se da cuenta de que está atrapado entre los dos mundos, y no para de ver algo que le atemoriza y le amenaza con un futuro terrible para todo el mundo en el pueblo de Hawkins. Once, que sobrevivió a su batalla con el Demogorgon, se encuentra a salvo con el Jefe Jim Hopper, pero El Mundo del Revés, volverá a sembrar el terror al propagarse de nuevo por Hawkins.

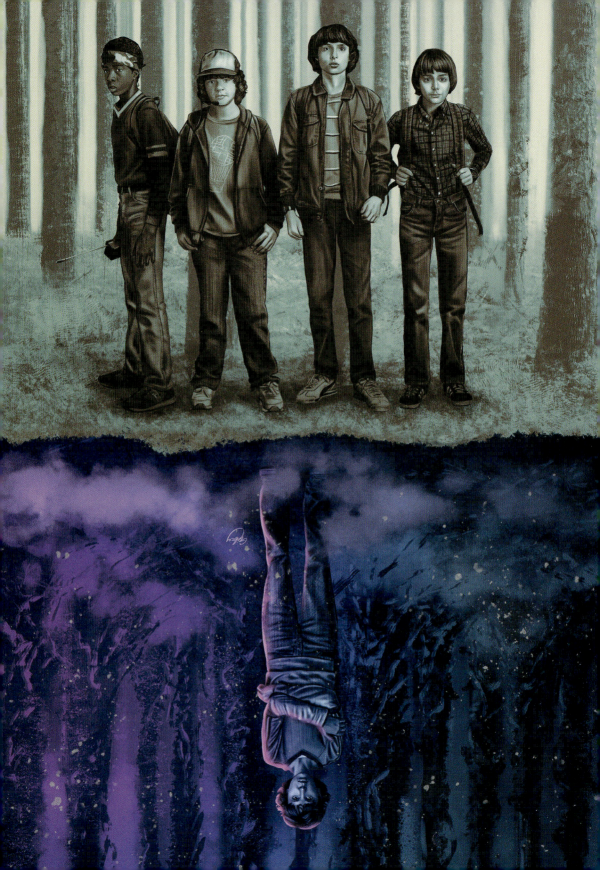

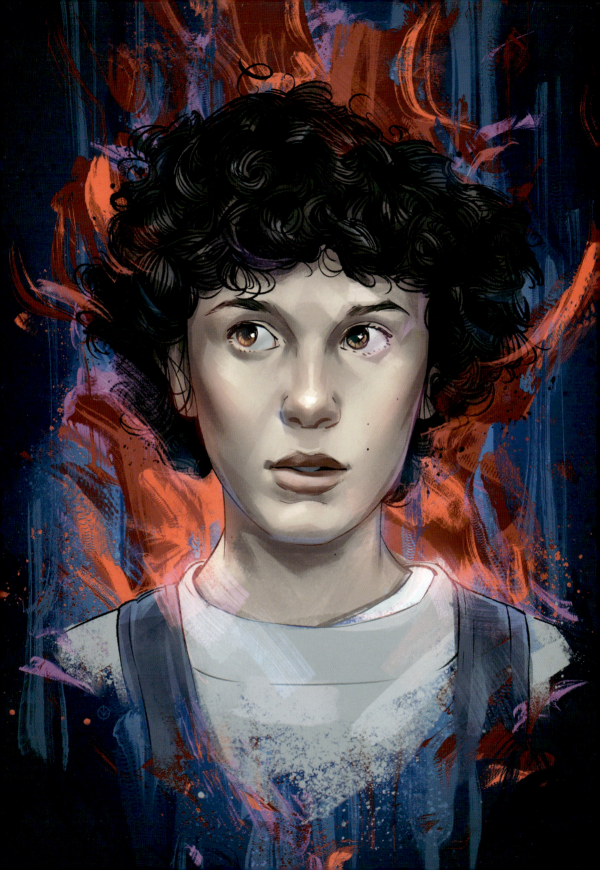

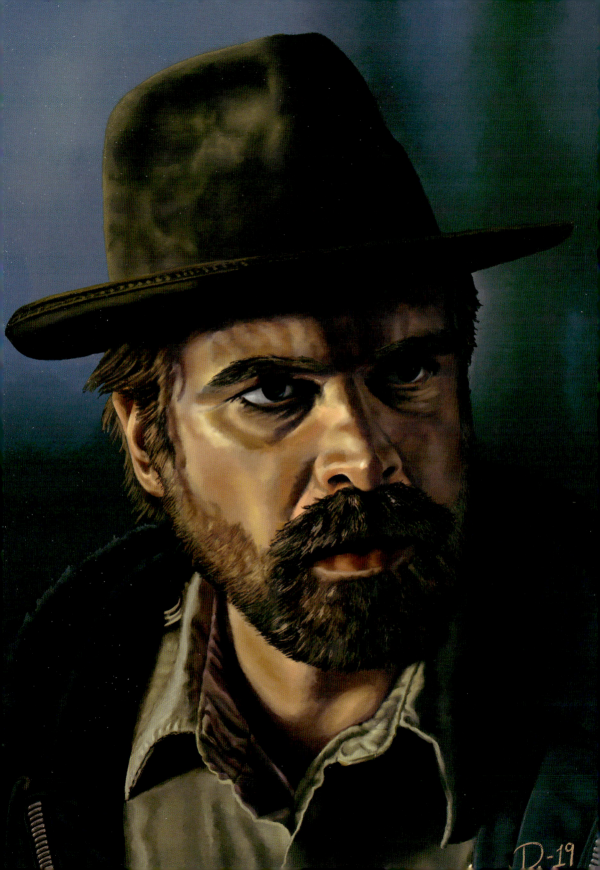

"THERE'S GONNA BE A COUPLE GROUND RULES.

ONE: ALWAYS KEEP THE CURTAINS DRAWN.

TWO: ONLY OPEN THE DOOR IF YOU HEAR MY SECRET KNOCK.

THREE: DON'T EVER GO OUT ALONE,

ESPECIALLY NOT IN THE DAYLIGHT"

"Tengo unas cuantas reglas.
Regla número uno: tener siempre las cortinas cerradas. Regla número dos: solo abrir la puerta si oyes mi llamada secreta. Y regla número tres: No salir nunca sola, y menos durante el día"
- Jim Hopper -

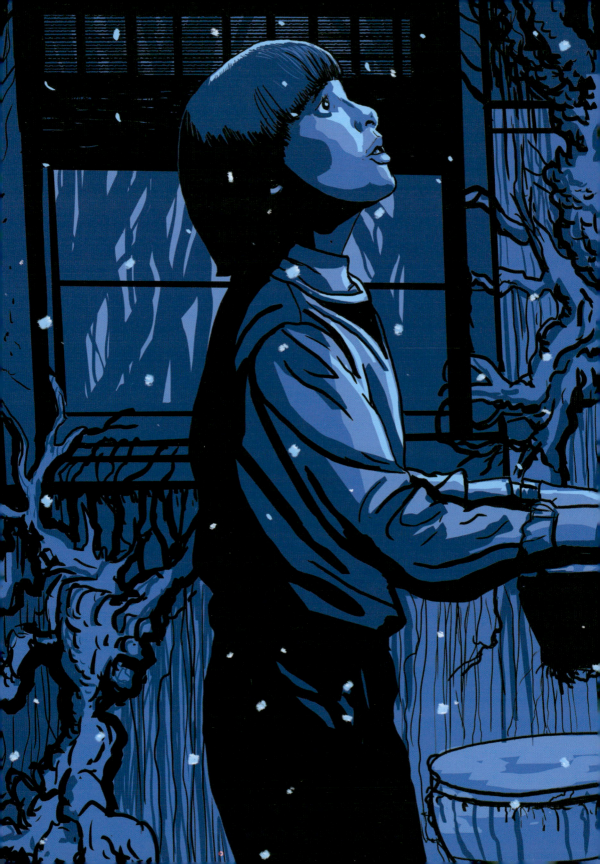

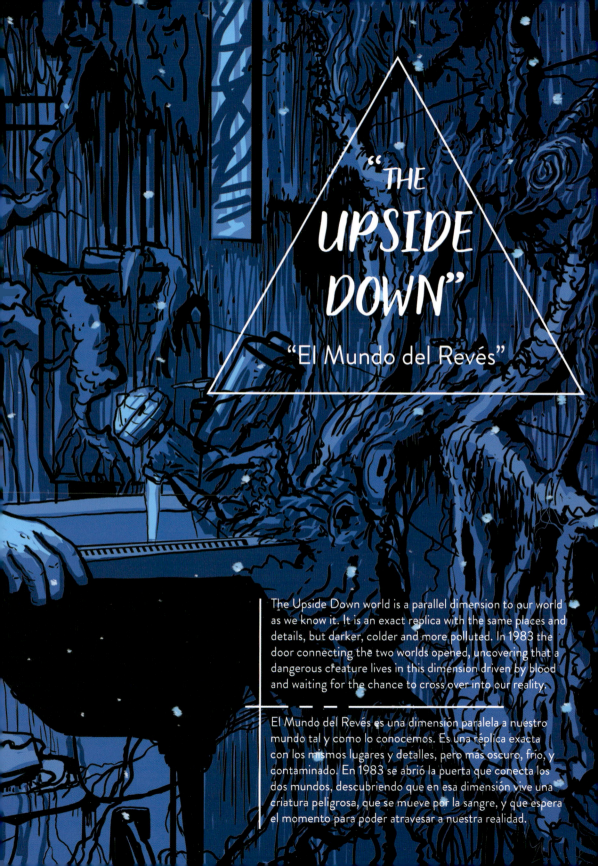

"THE UPSIDE DOWN"

"El Mundo del Revés"

The Upside Down world is a parallel dimension to our world as we know it. It is an exact replica with the same places and details, but darker, colder and more polluted. In 1983 the door connecting the two worlds opened, uncovering that a dangerous creature lives in this dimension driven by blood and waiting for the chance to cross over into our reality.

El Mundo del Revés es una dimensión paralela a nuestro mundo tal y como lo conocemos. Es una réplica exacta con los mismos lugares y detalles, pero más oscuro, frío, y contaminado. En 1983 se abrió la puerta que conecta los dos mundos, descubriendo que en esa dimensión vive una criatura peligrosa, que se mueve por la sangre, y que espera el momento para poder atravesar a nuestra realidad.

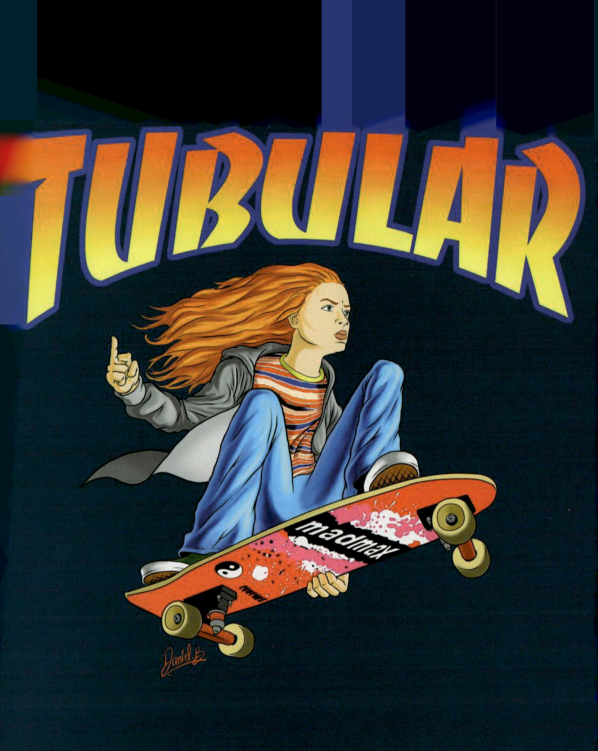

TUBULAR

Daniel. &

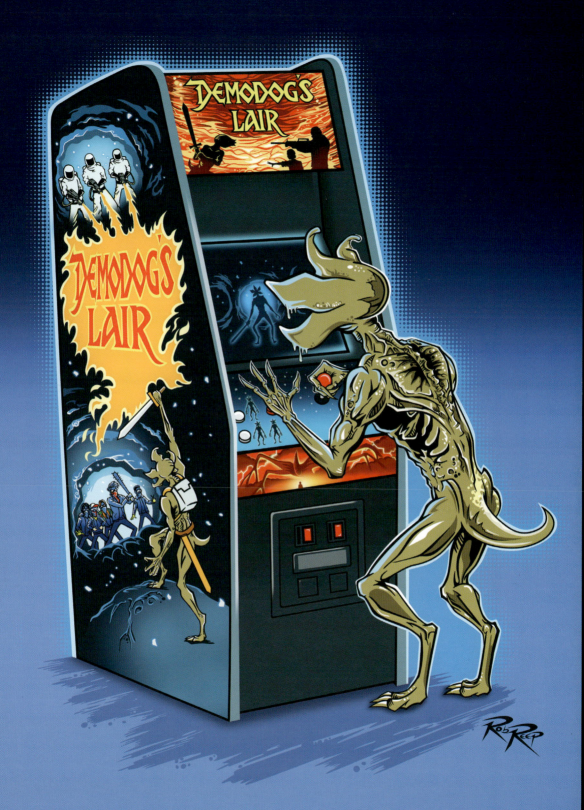

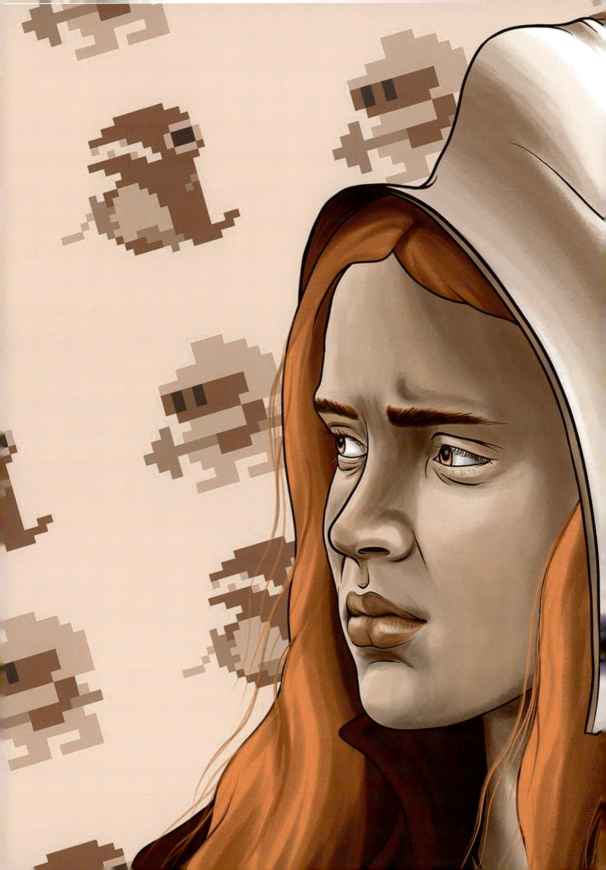

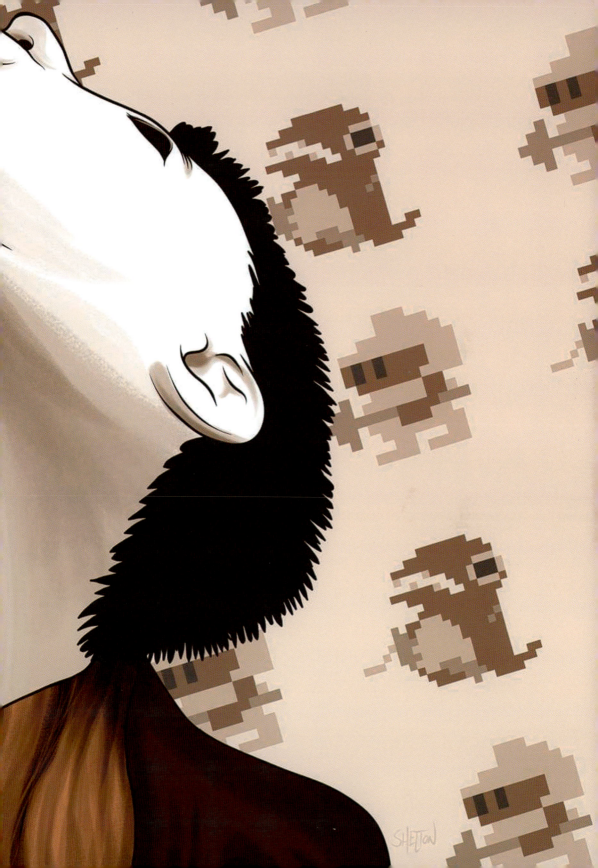

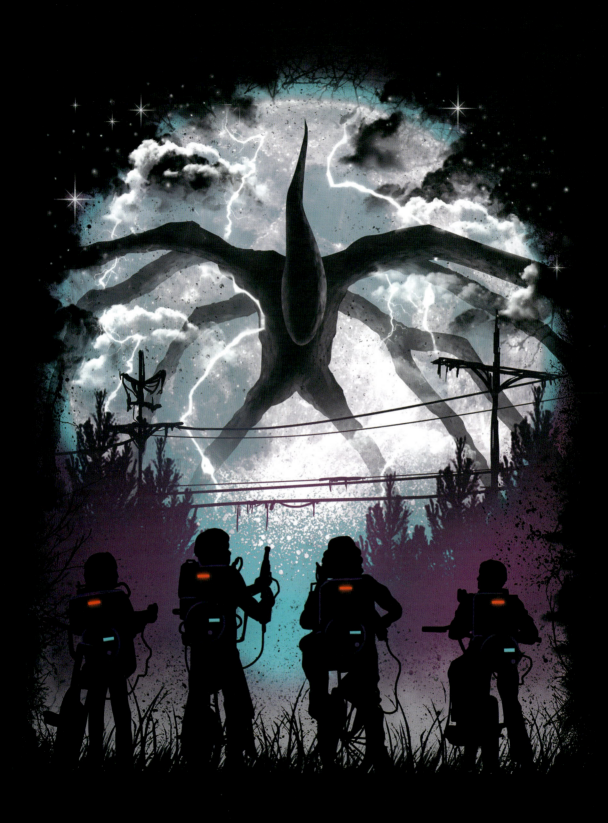

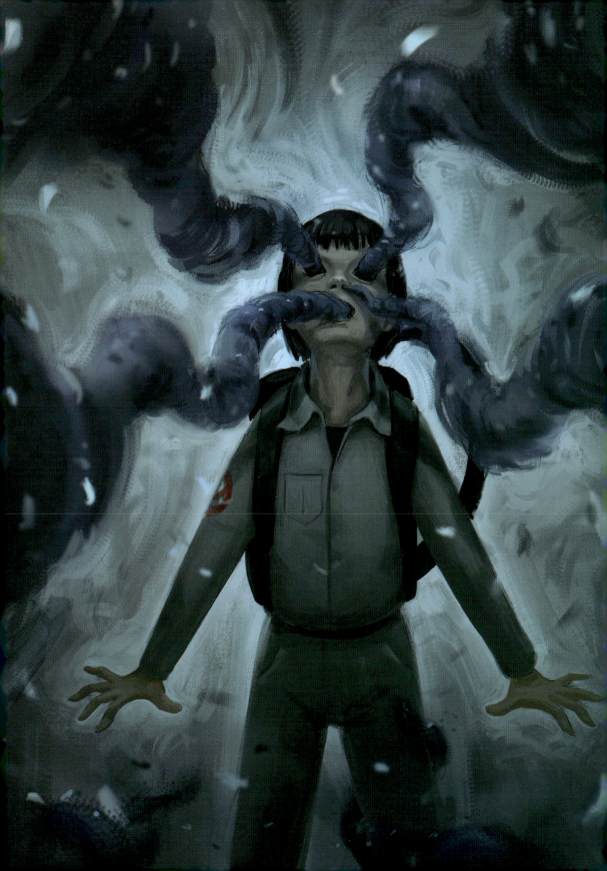

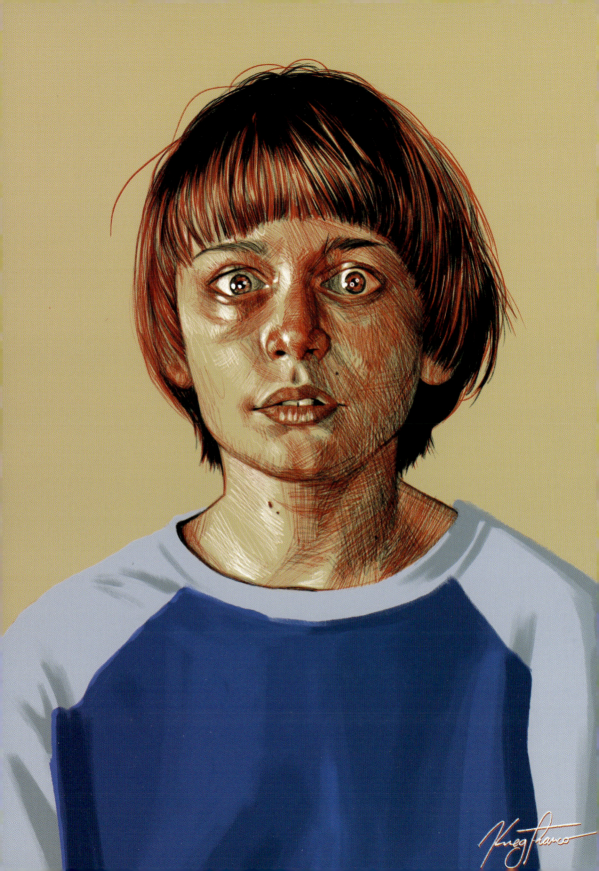

"IT WAS LIKE THIS HUGE SHADOW IN THE SKY.

ONLY, IT WAS ALIVE.

AND IT WAS COMING FOR ME"

"Era como una sombra enorme en el cielo.
Pero, estaba viva e iba a por mí"

- Will Byers -

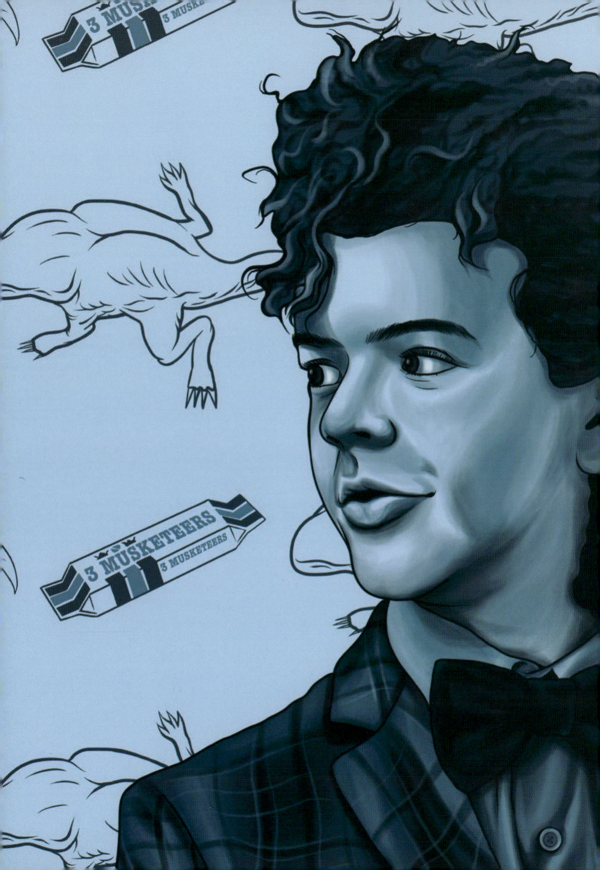

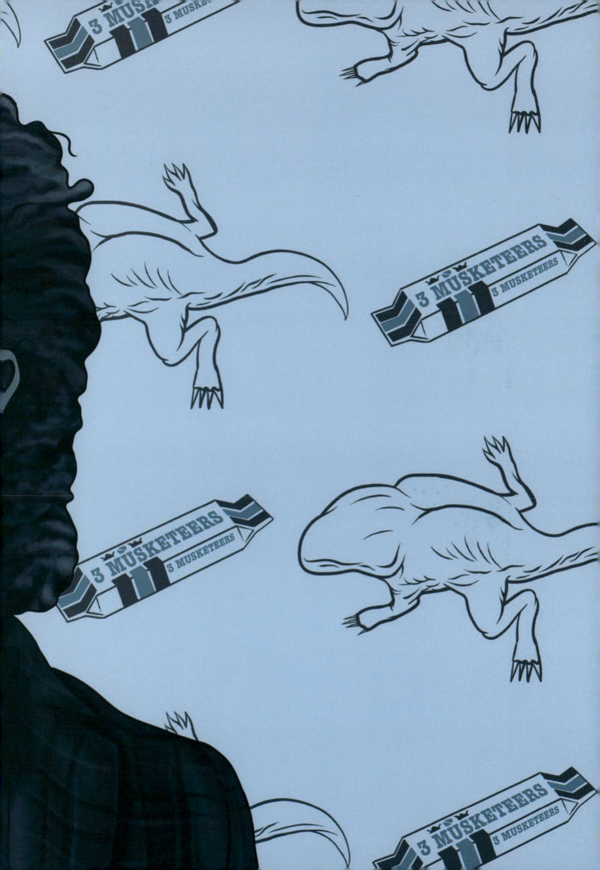

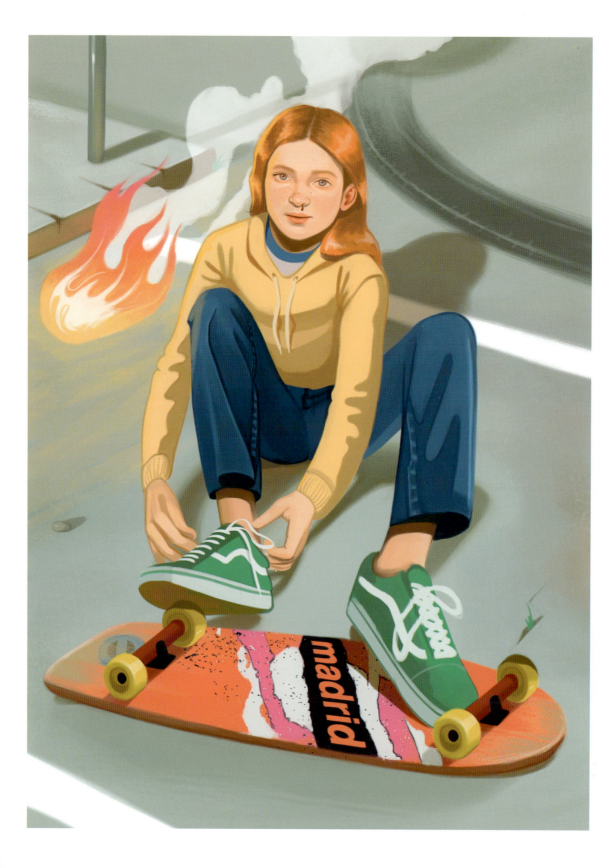

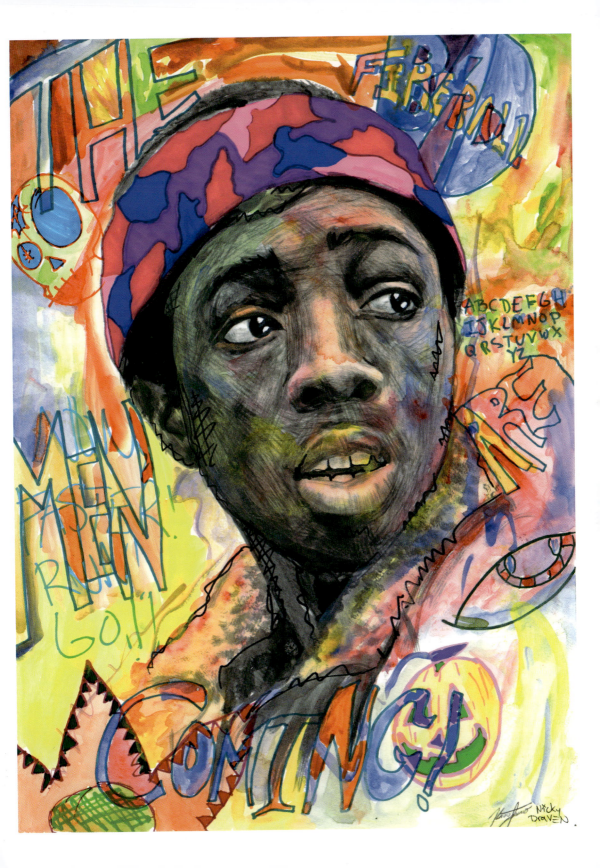

"NOBODY CALLS ME MAXINE...

IT'S MAX"

"Nadie me llama Maxine... Es Max"

- Max Mayfield -

Max Mayfield "MadMax" was born in California, where she lived until she moved to Hawkins, due to her parents' divorce and her mother's new marriage.
Max has many hobbies that some would not consider "normal" for a girl. She likes skateboarding and is an expert in Arcade Games, where she gets the best scores.

Due to her stepbrother's abusive treatment of her she is distrustful and sceptical. When Lucas and Dustin meet her they are fascinated and try to become friends, and although she initially rejects them, she later wants to become a member of the group.

Max Mayfield "MadMax", nació en California, lugar donde vivió hasta que se mudó a Hawkins, debido al divorcio de sus padres y al nuevo matrimonio de su madre. Max tiene muchas aficiones que algunos no considerarían "normales" para una niña. Le gusta mucho el skateboarding y es experta en Juegos de Arcade, donde es capaz de conseguir las mejores puntuaciones.

Debido al trato abusivo de su hermanastro hacia ella, su actitud es desconfiada y escéptica. Nada más conocerla, Lucas y Dustin quedan fascinados e intentan hacerse sus amigos, y aunque inicialmente ella les rechaza, más tarde quiere convertirse en un miembro del grupo.

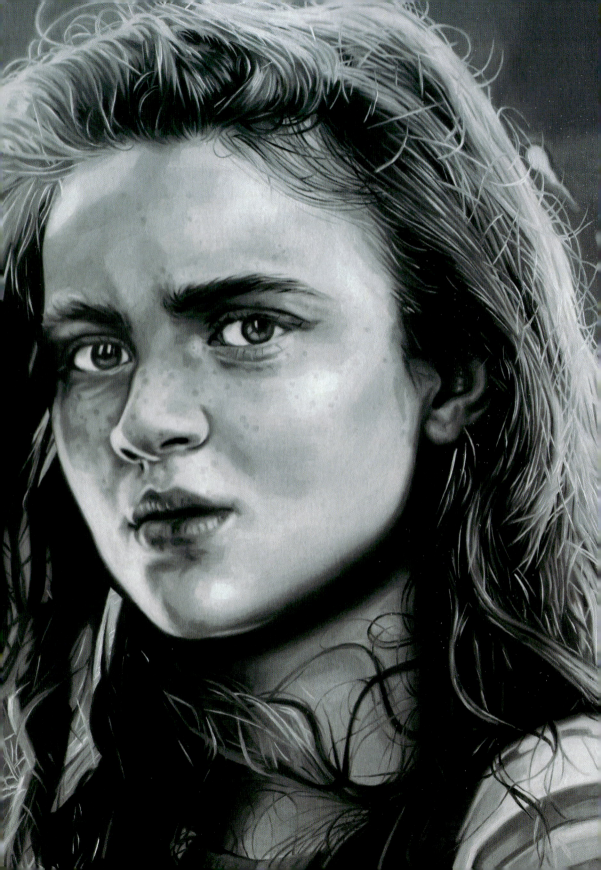

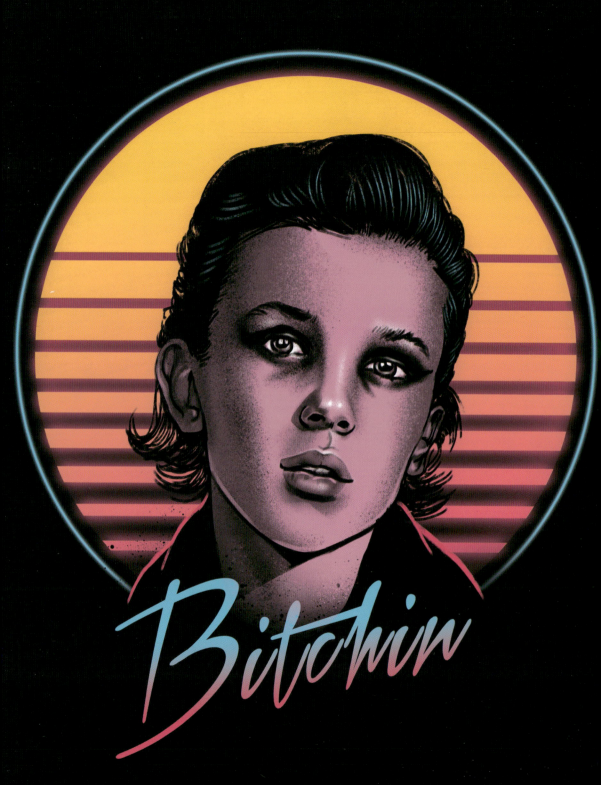

"I WAS JUST LIKE YOU ONCE,

I KEPT MY ANGER INSIDE. I TRIED TO HIDE FROM IT,

BUT THEN THAT PAIN FESTERED.

IT SPREAD. UNTIL FINALLY I CONFRONTED MY PAIN,

AND I BEGAN TO HEAL"

"Yo también era como tú, me guardaba toda la ira dentro. Intenté esconderme de ella, pero el dolor se infectó. Se extendió. Hasta que al final me enfrenté al dolor y empecé a curarme"

— Kali —

Kali, like Eleven, was subject of several experiments at the Hawkins National Laboratory. She has the gift of manipulating the mind of others, inducing them to see and hear something nonexistent. Kali's desire is to be with Eleven, to find a way to defeat the people who hurt them in the past.

Kali al igual que Once, fue objeto de varios experimentos en el Laboratorio Nacional de Hawkins. Tiene el don de manipular la mente, induciendo a su objetivo a que vea y escuche algo inexistente. El deseo de Kali es seguir junto a Once, para buscar la manera de poder acabar con las persona que les hicieron daño en el pasado.

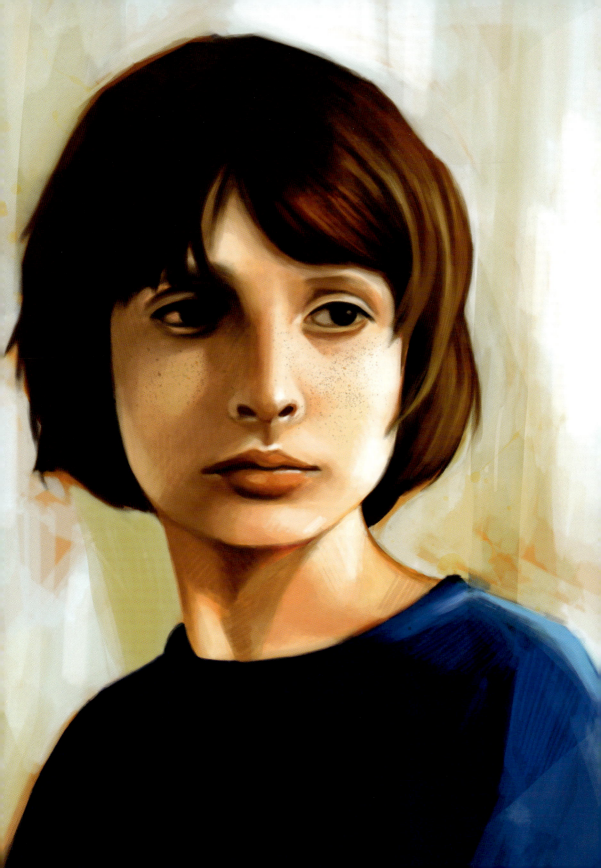

"I NEVER GAVE UP ON YOU. I CALLED YOU EVERY NIGHT. EVERY NIGHT FOR... 353 DAYS"

"No me rendí nunca. Te llamaba todas las noches, cada noche durante... 353 días"

- Mike Wheeler -

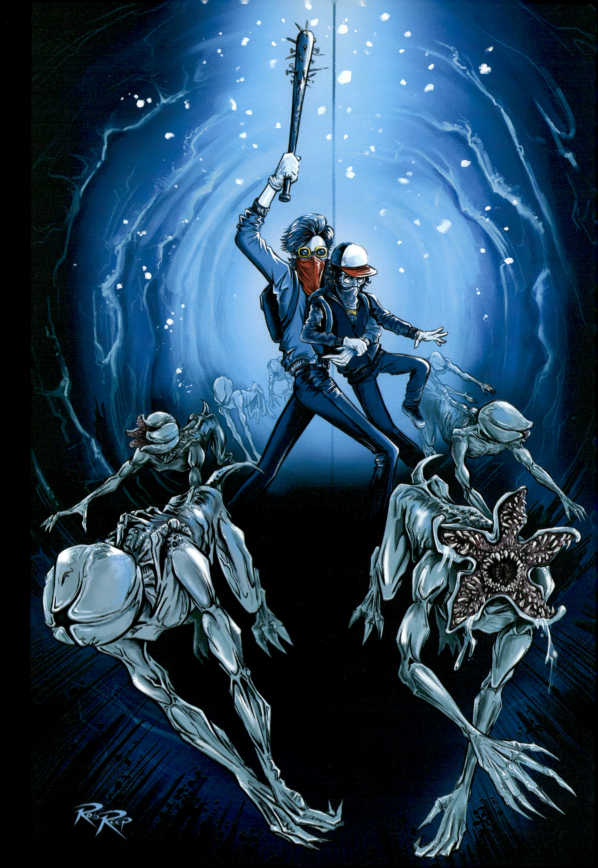

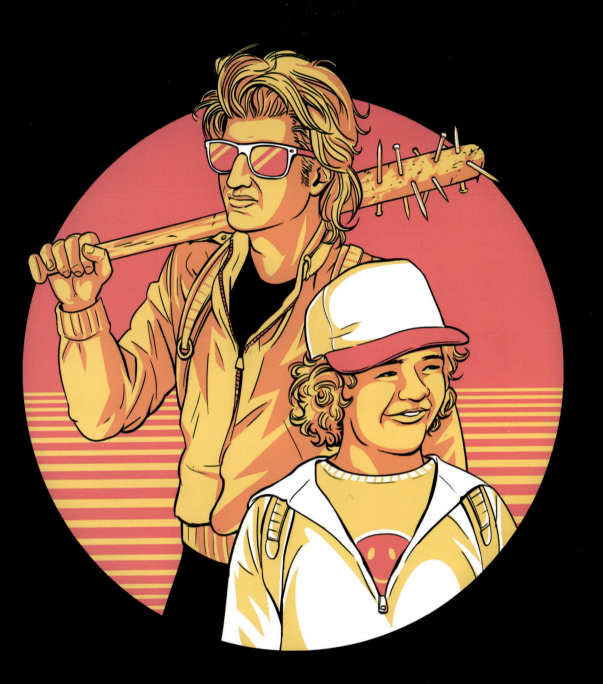

PRETTY DAMN GOOD
BABYSITTER

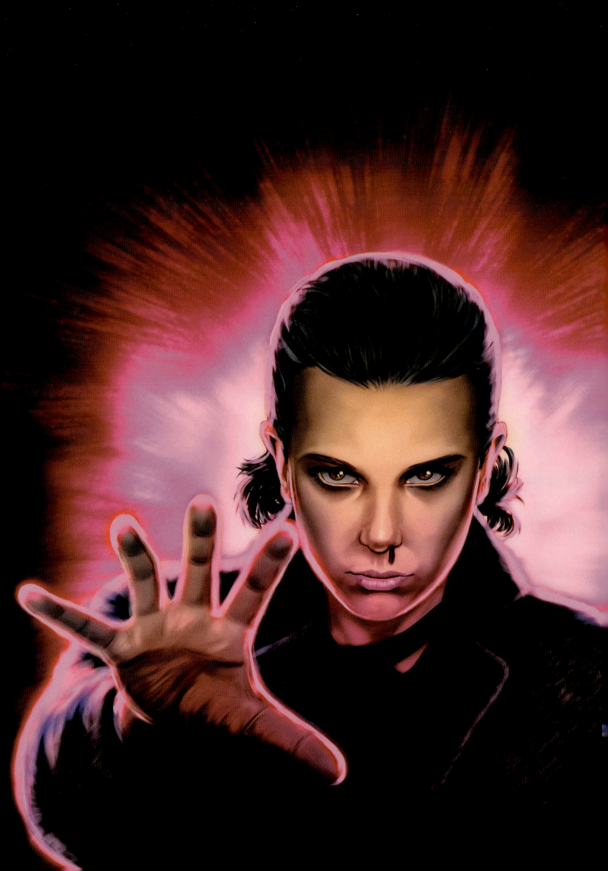

"I'M GOING TO MY FRIENDS. I'M GOING HOME"

"Vuelvo con mis amigos. Me voy a casa"

- Eleven -

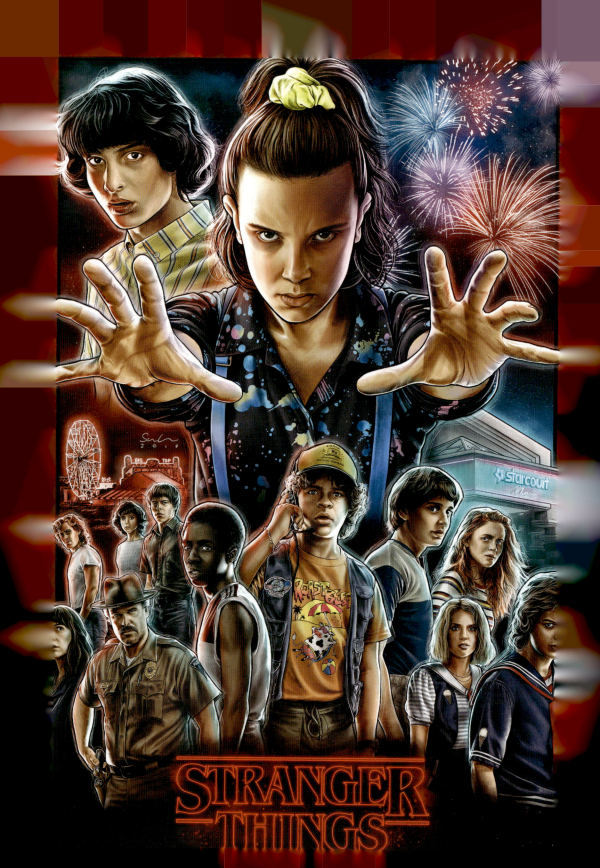

Chapters: Suzie, Do You Copy?. The Malls Rats. The Case of The Missing Lifeguard. The Sauna Test. The Flayed. E Pluribus Unum. The Bite. The Battle of Starcourt.

Summer 1985, in Hawkins, Indiana, the sun is already hot, school is over and a new mall has been opened in town. The group of inseparable friends are in blossoming adolescence and romances begin to flourish, which will complicate relations between them. They will have to learn to respect each other to continue to grow up together without separating. Meanwhile Hawkins is threatened again by old and new enemies. Eleven and her friends remember that evil never ends but evolves. They will have to team up to survive and remember that their friendship is always stronger than everything.

Verano de 1985, en Hawkins, Indiana, el sol ya calienta, se ha acabado el colegio, y han abierto un nuevo centro comercial en el pueblo. El grupo de amigos inseparables se encuentra en plena adolescencia y empiezan a florecer los romances, que complicarán las relaciones entre ellos. Tendrán que aprender a respetarse para poder seguir creciendo juntos sin separarse. Mientras tanto Hawkins vuelve a verse amenazado por viejos enemigos. Once y sus amigos recuerdan que el mal nunca acaba sino que evoluciona. Tendrán que formar equipo para sobrevivir y recordar que su amistad siempre es más fuerte que todo.

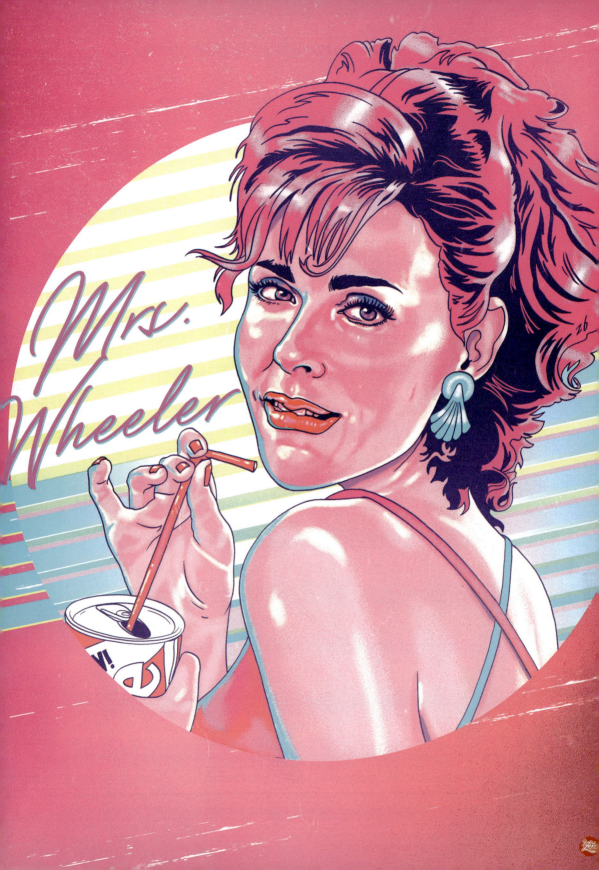

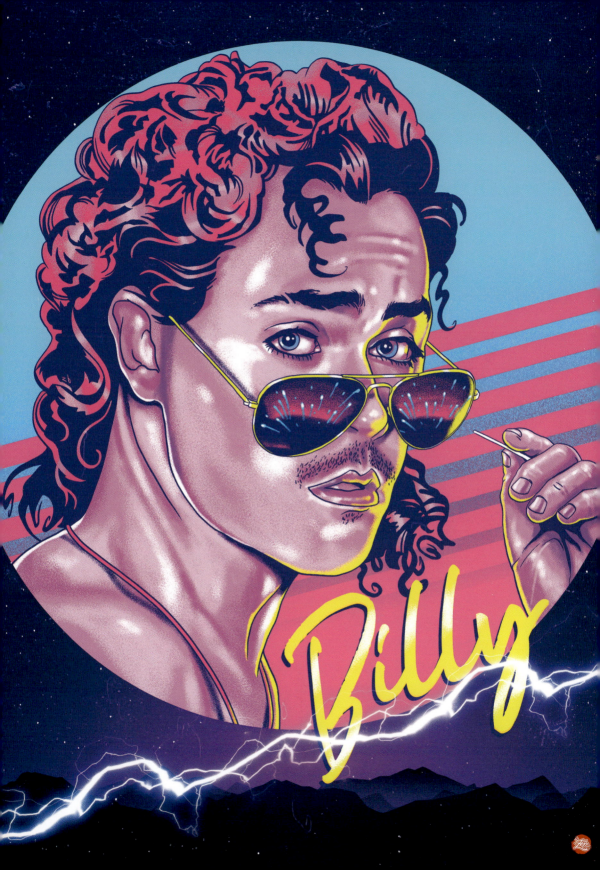

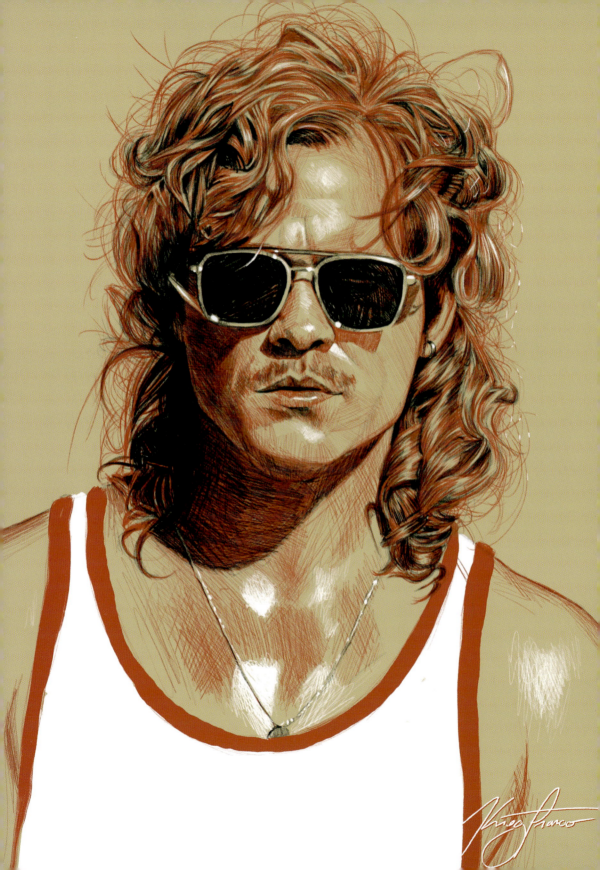

"LADIES,
SHE'S COMING DOWN.
AND... SHOWTIME"

"Señoritas, ella ya baja... Que empiece el show"

- Milf -

Billy Hargrove is the bad boy of Stranger Things, he is 17 years old, and he is one of Hawkins' most popular boys. He is a seducer, muscular, arrogant, nervous and with a violent and unpredictable nature.

Billy Hargrove es el chico malo de Stranger Things, tiene 17 años, y es uno de los chicos más populares de Hawkins. Es todo un seductor, musculoso, prepotente, nervioso y con una naturaleza violenta e impredecible.

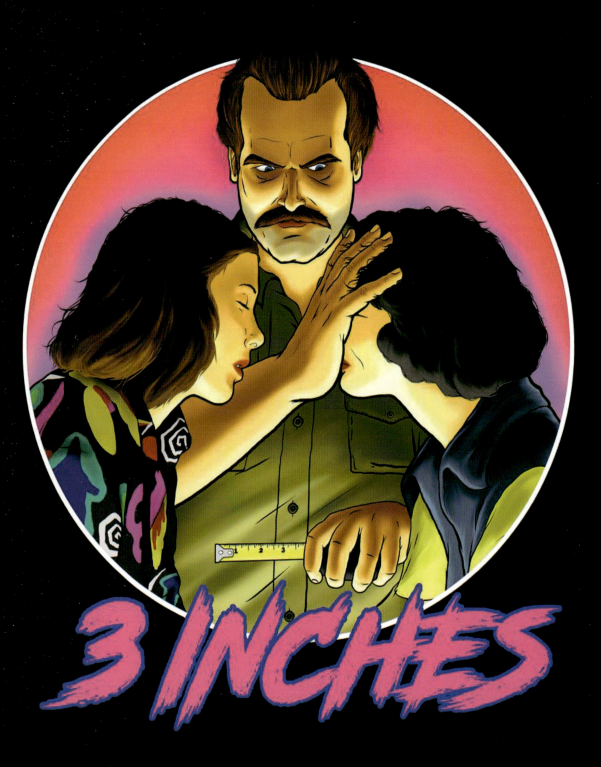

3 INCHES

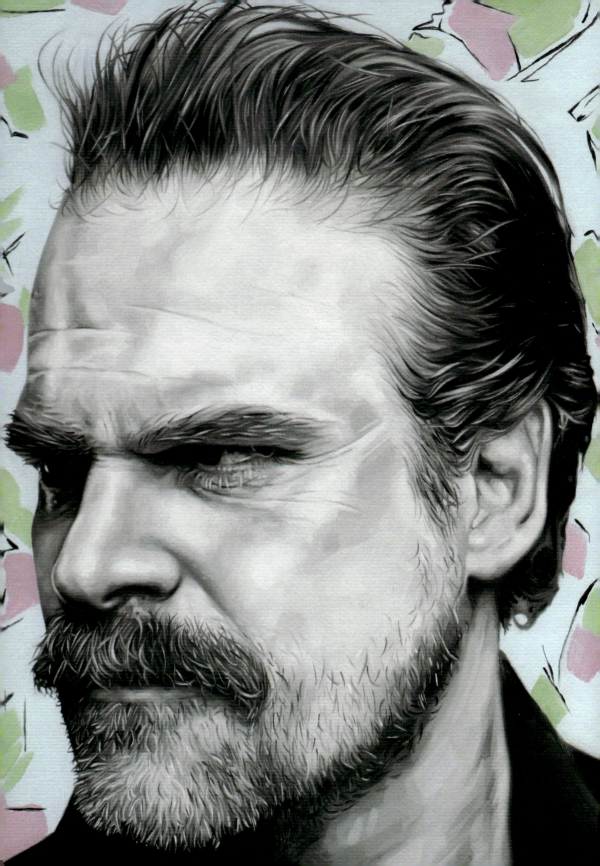

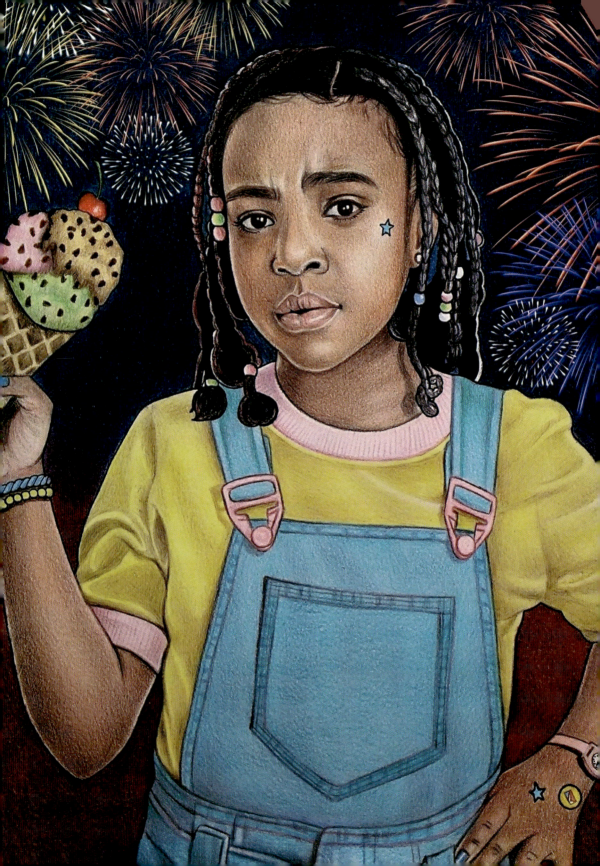

"YOU CAN'T SPELL AMERICA WITHOUT ERICA"

"No se escribe América sin Erica"

- Erica Sinclair -

Erica is Lucas's little sister who gets on his nerves. We meet her briefly in the second season, but it is in the third where we discover an intelligent, brave girl, who defends her opinions and will not be bullied by anyone. When Dustin, Steve and Robin ask for help to enter the ventilation pipe she analyses the situation, assesses the risks and asks for her reward:
Free ice cream for life!

Erica es la hermana pequeña de Lucas, y una fuente de irritación para él. La conocemos brevemente en la segunda temporada, pero es en la tercera donde descubrimos a una niña inteligente, valiente, que defiende sus opiniones y no se deja intimidar por nadie. Cuando Dustin, Steve y Robin le piden ayuda para que entre al conducto de ventilación, ella analiza la situación, evalúa los riesgos y plantea la recompensa que considera: ¡Helado gratis para el resto de su vida!

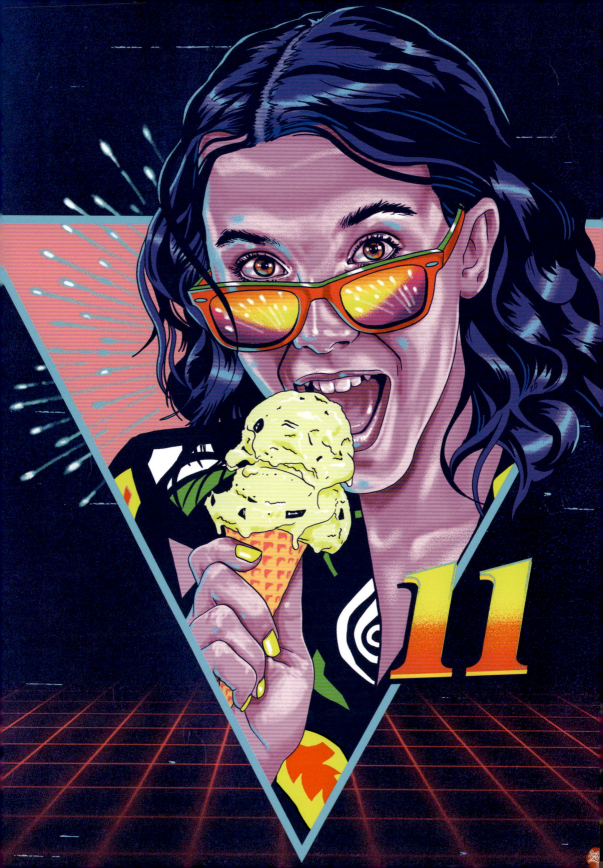

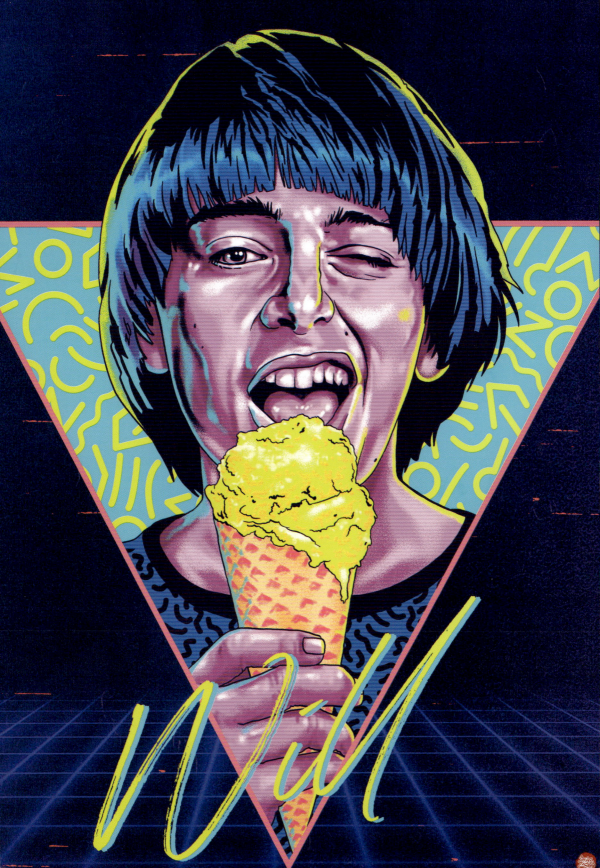

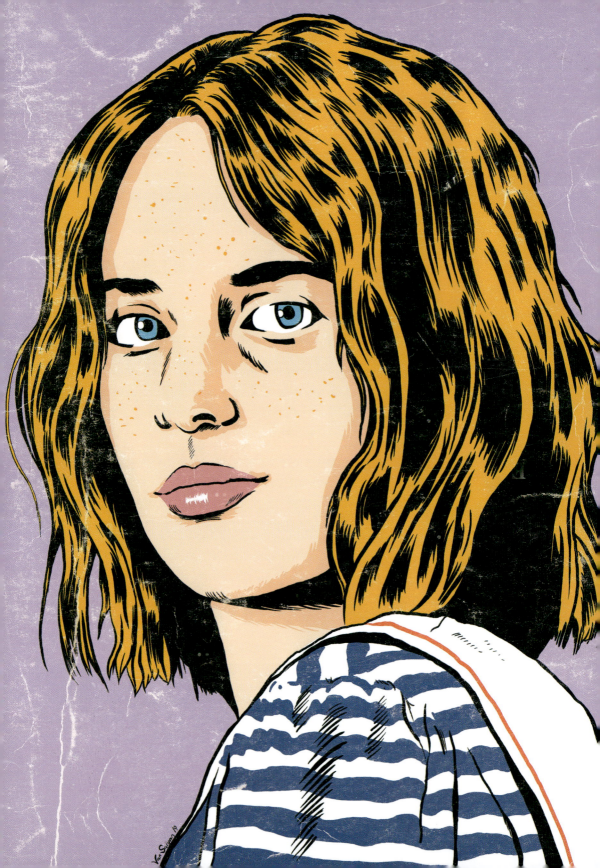

"YOU RULE - YOU SUCK"

||||| |

- Robin Buckley -

Robin is Steve's co-worker in the new ice cream parlour in the mall. She is a very clever girl who is fluent in several languages. She is bored in her humdrum job and struggles to find strong emotions in her life. She finally succeeds becoming a member of "Scoops Troop" and helping to discover a dark secret that surrounds Hawkins.

Robin es la compañera de trabajo de Steve en la nueva heladería del centro comercial. Es una chica muy inteligente que tiene fluidez en varios idiomas. Se siente aburrida por su rutinario trabajo, y lucha por buscar emociones fuertes en su vida. Finalmente lo consigue formando parte de "Scoops Troop", y ayudando a descubrir un oscuro secreto que envuelve Hawkins.

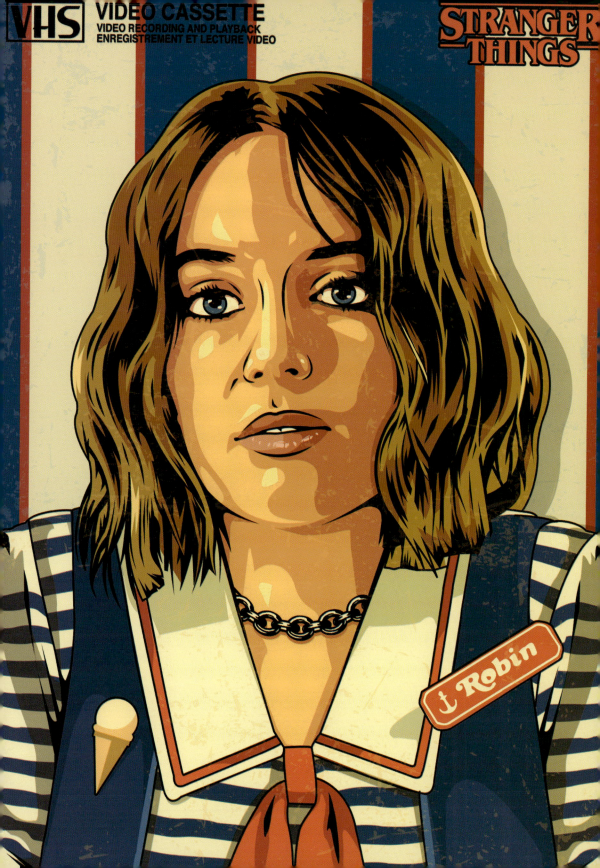

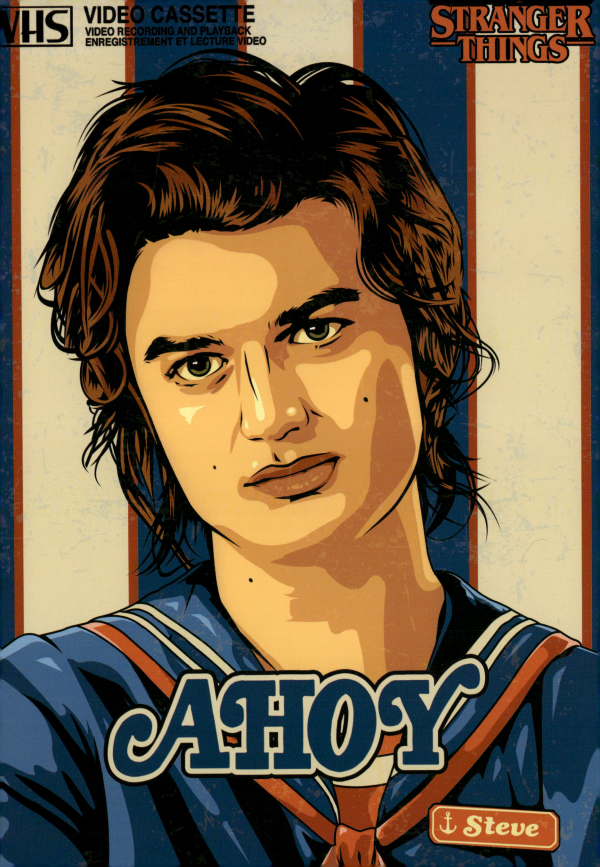

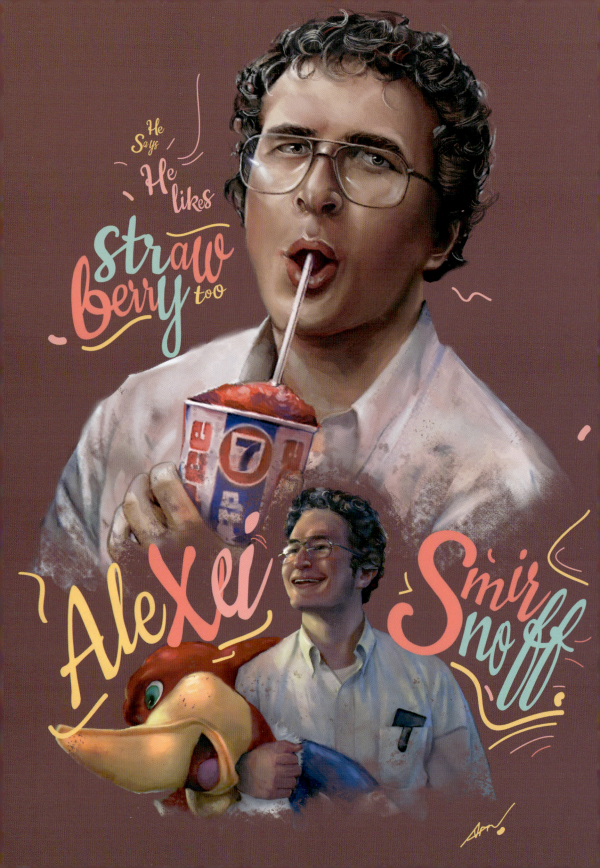

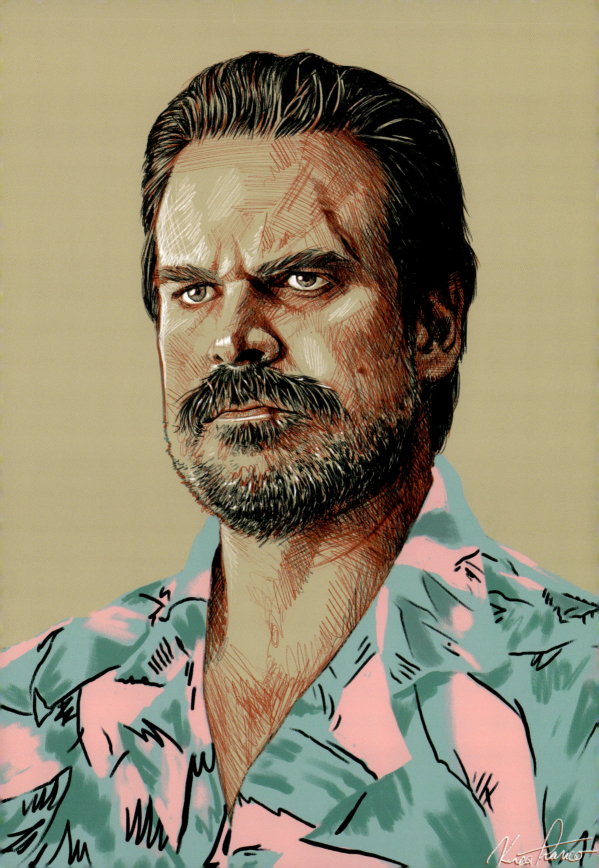

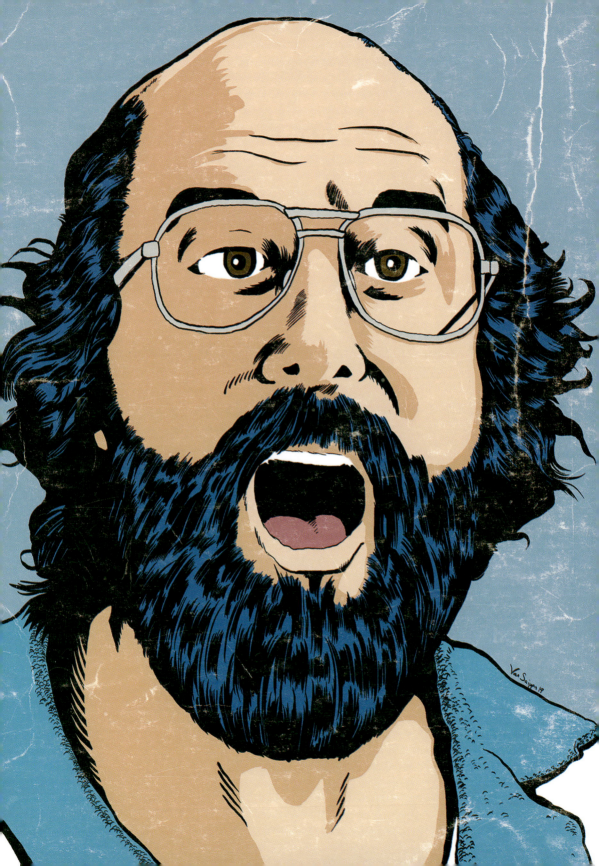

"BALD EAGLE. MASTER OF THE CONSPIRACIES"

"Águila calva. Maestro de las conspiraciones"

- Dustin Henderson -

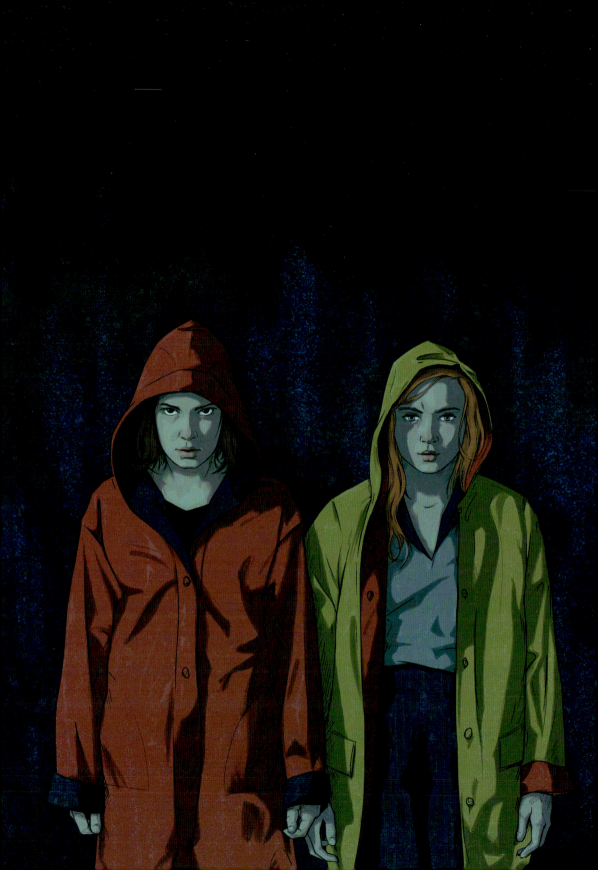

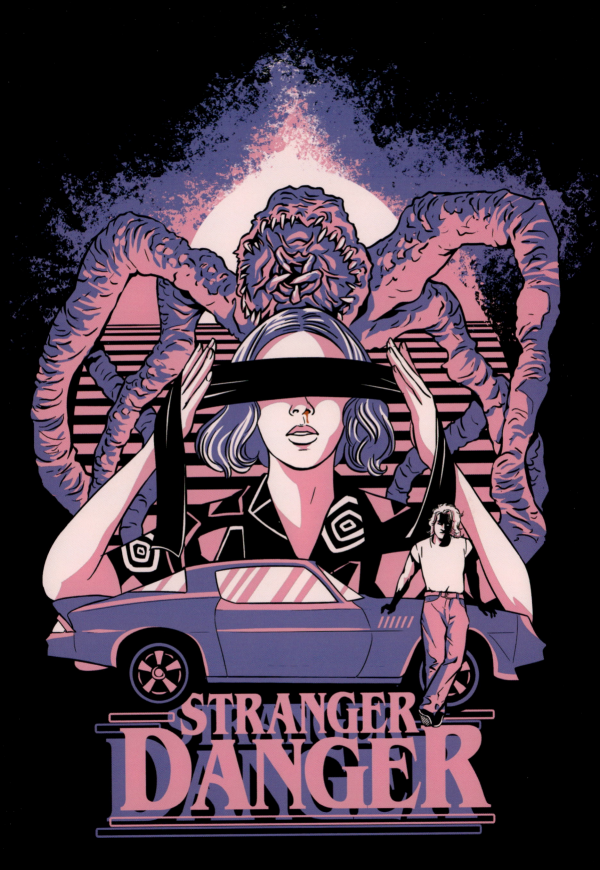

WELCOME
TO
HAWKINS

...it's
cold here

WE ARE
NOT IN
HAWKINS
ANYMORE

@DANA_MALISH

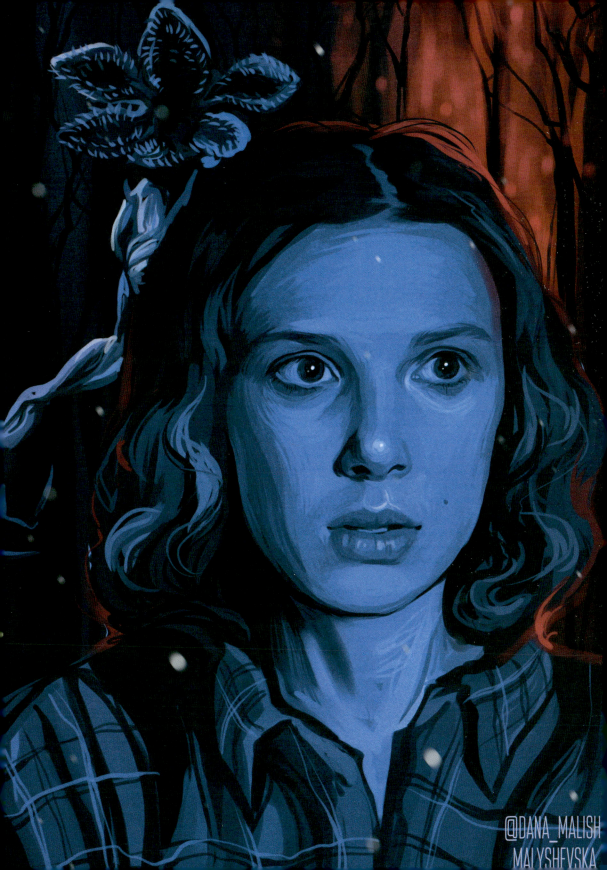

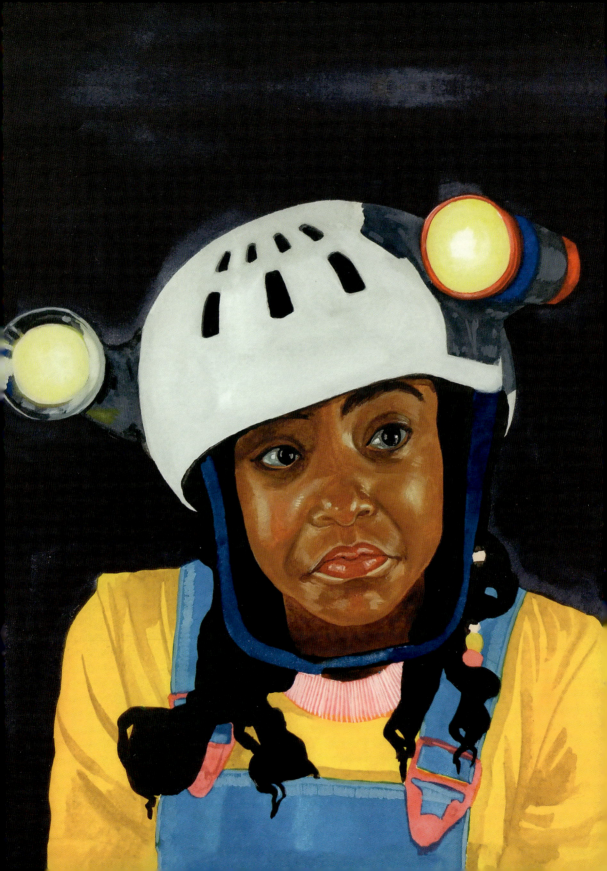

"COMMENCE
OPERATION
CHILD ENDANGERMENT"

"Empieza la operación: Imprudencia Temeraria"

- Erica Sinclair -

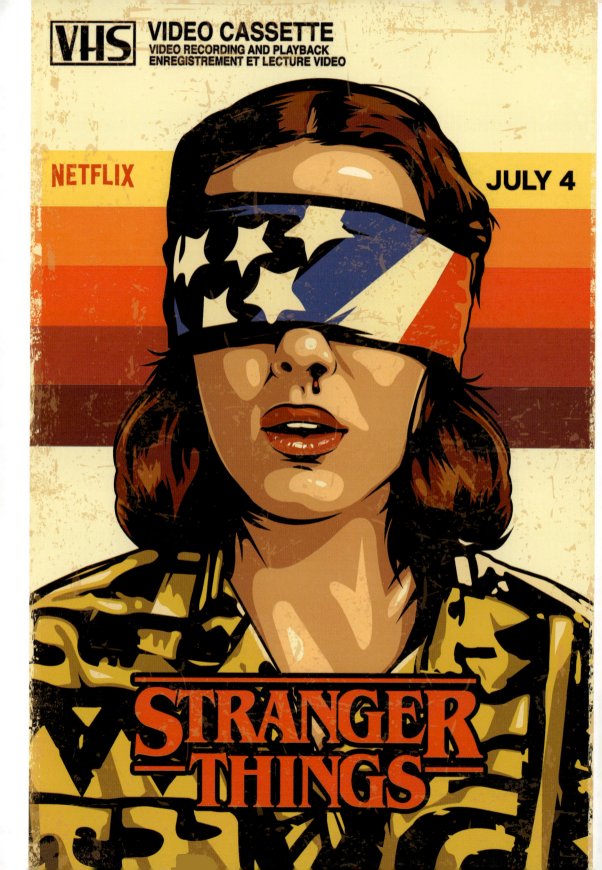

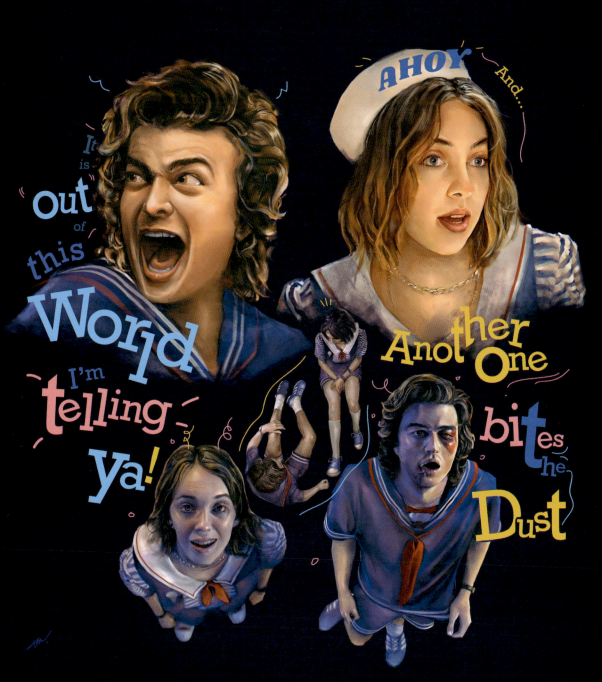

"PLANCK'S CONSTANT IS 6.62607004"

- Dusty-bun & Suzie-poo -

"Turn around
Look at what you see
In her face
The mirror of your dreams
Make believe I'm everywhere
Given in the light
Written on the pages
Is the answer to a never ending story
Ah
Reach the stars
Fly a fantasy
Dream a dream
And what you see will be
Rhymes that keep their secrets
Will unfold behind the clouds
And there upon a rainbow
Is the answer to a never ending story
Ah...Story.... Ah"

Original song 1984 - Gorgio Moroder | Artist Limahl

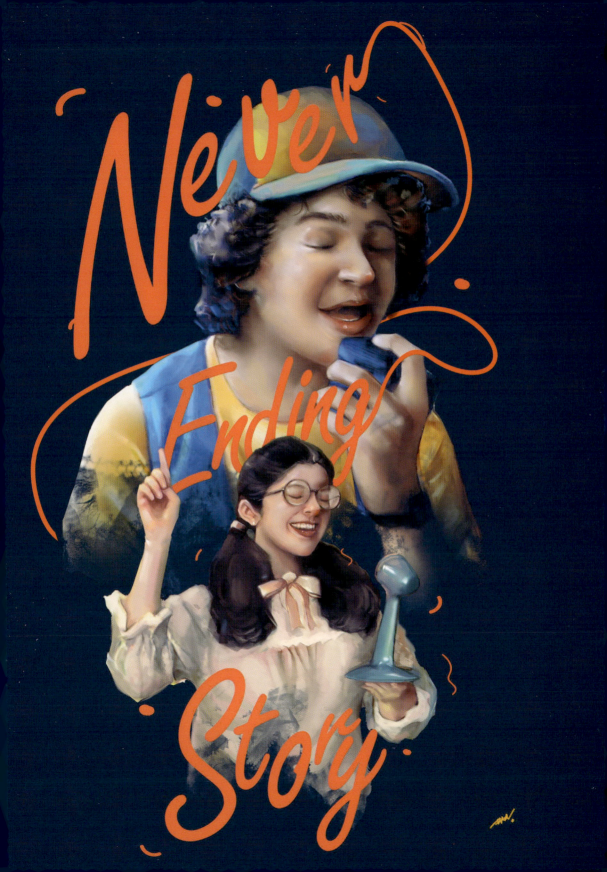

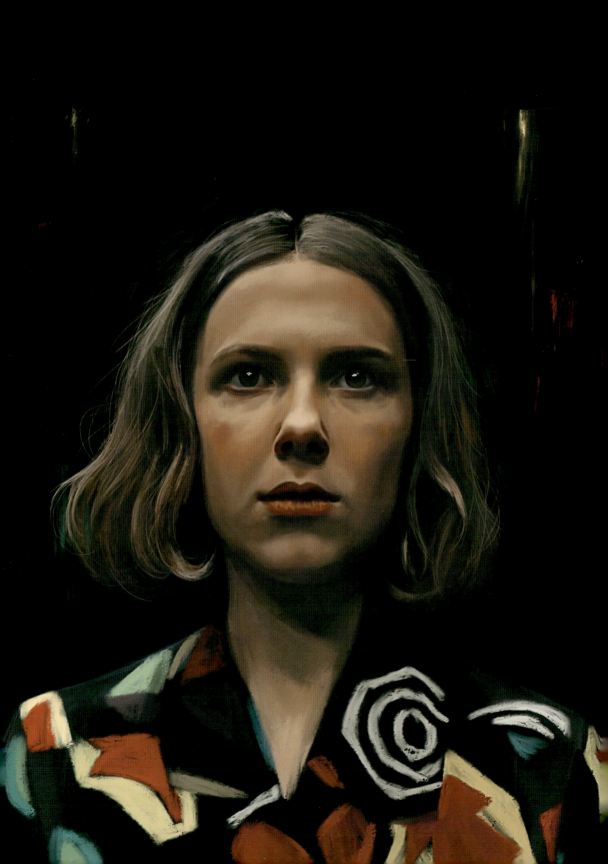

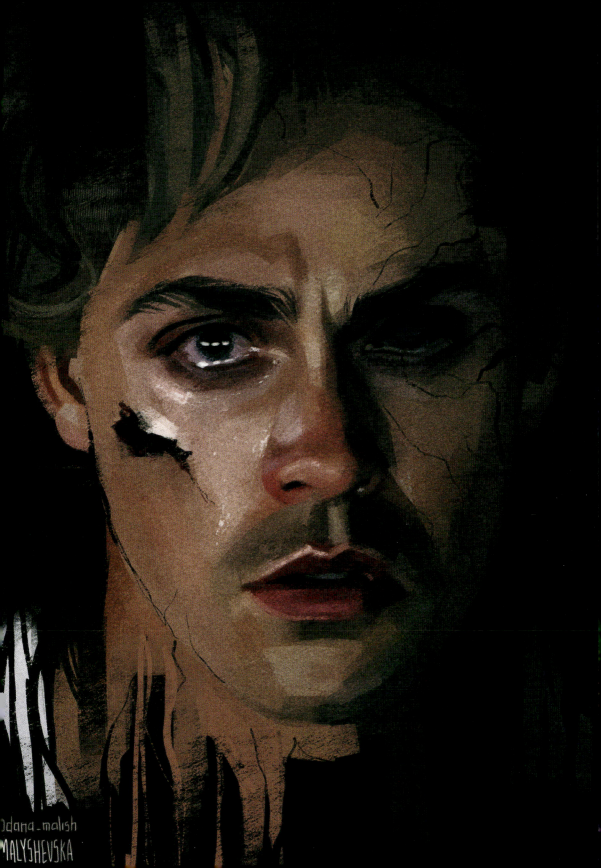

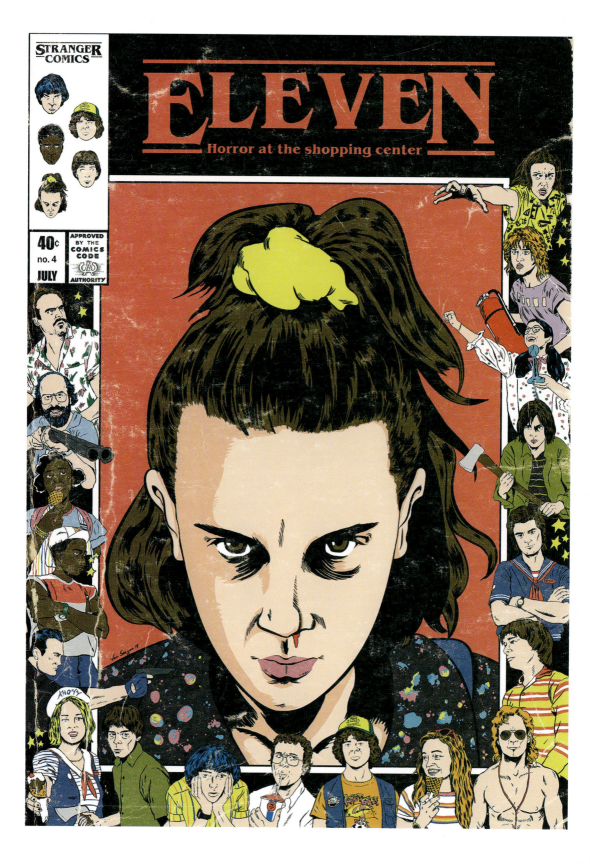

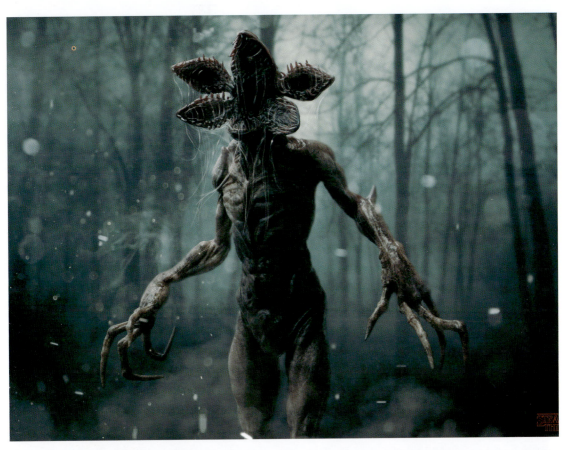

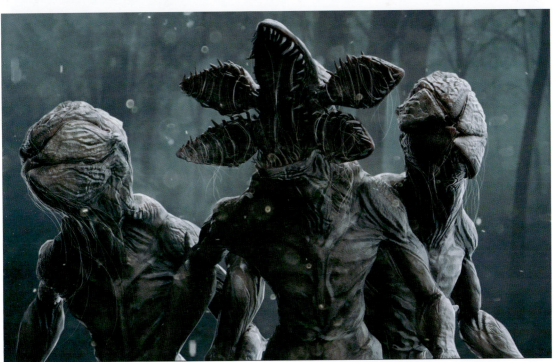

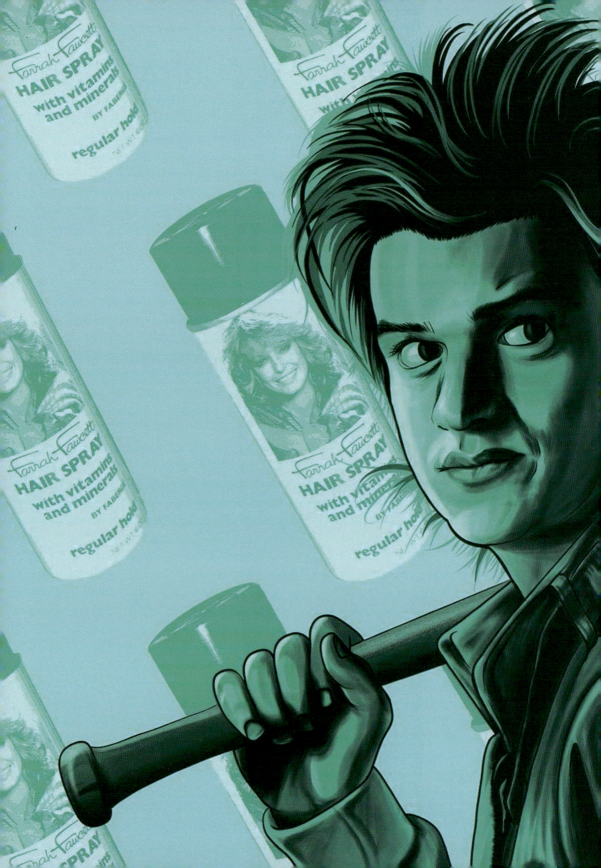

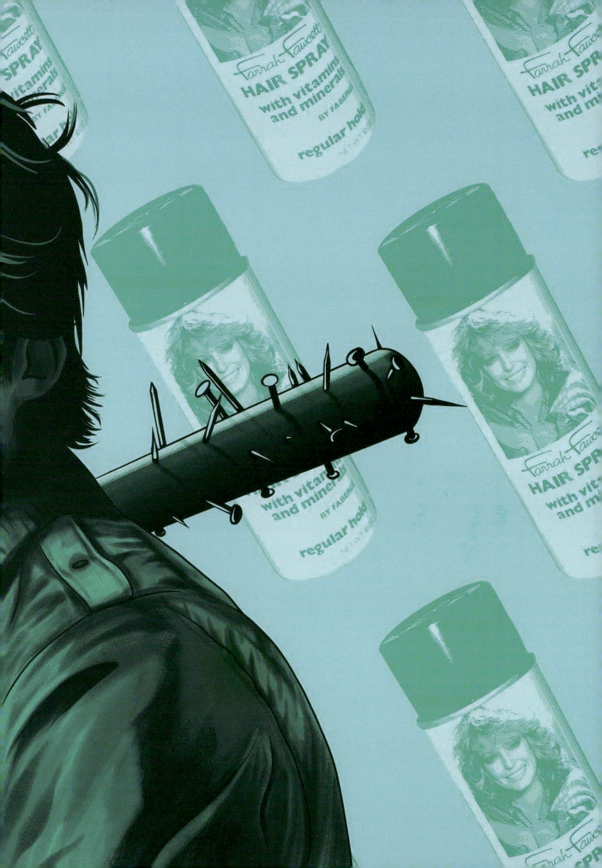

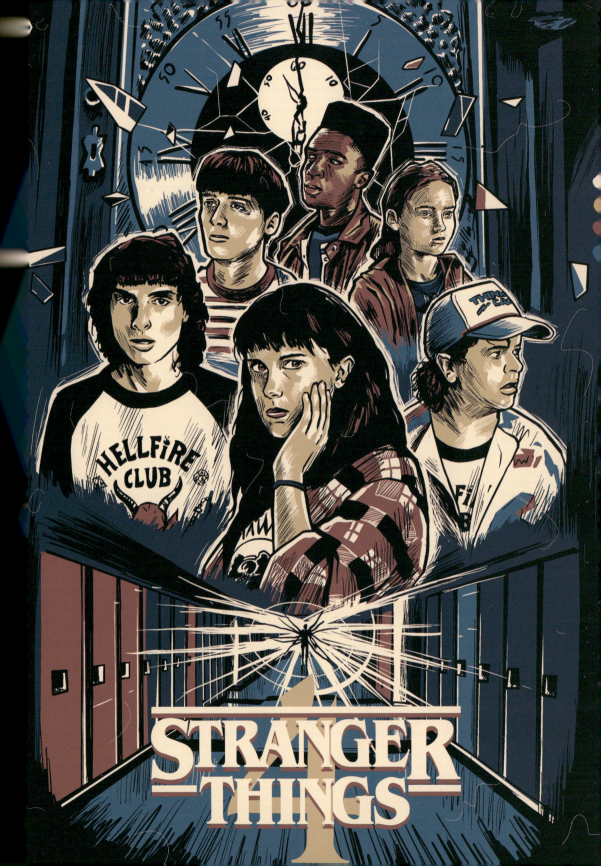

Chapters: The Hellfire Club. Vecna's Curse. The Monster and the Superhero. Dear Billy. The Nina Project. The Dive. The Massacre at Hawkins Lab. Papa. The Piggyback.

March 1986, eight months have passed since the Battle of Starcourt, which brought terror and destruction to Hawkins. Struggling with the aftermath, our group of friends are separated for the first time, with Eleven and the Byers family moving to California. Meanwhile, we are shown the complicated daily lives of our main characters in high school. At this vulnerable time, a horrible new supernatural threat emerges in Hawkins. The strange death of a cheerleader opens the plot to a gruesome mystery that if solved, could finally put an end to the horrors of the Upside Down.

Marzo de 1986, han pasado ocho meses desde la Batalla de Starcourt, que trajo terror y destrucción a Hawkins. Luchando con las secuelas, nuestro grupo de amigos se separa por primera vez, trasladando a Once y a la familia Byers a California. Mientras nos muestran el día a día complicado de nuestros protagonistas en la escuela secundaria. En este momento más vulnerable, surge una nueva y horrible amenaza sobrenatural en Hawkins, la extraña muerte de una animadora, abre la trama a un espantoso misterio que si se resuelve, finalmente podría poner fin a los horrores del Mundo del Revés.

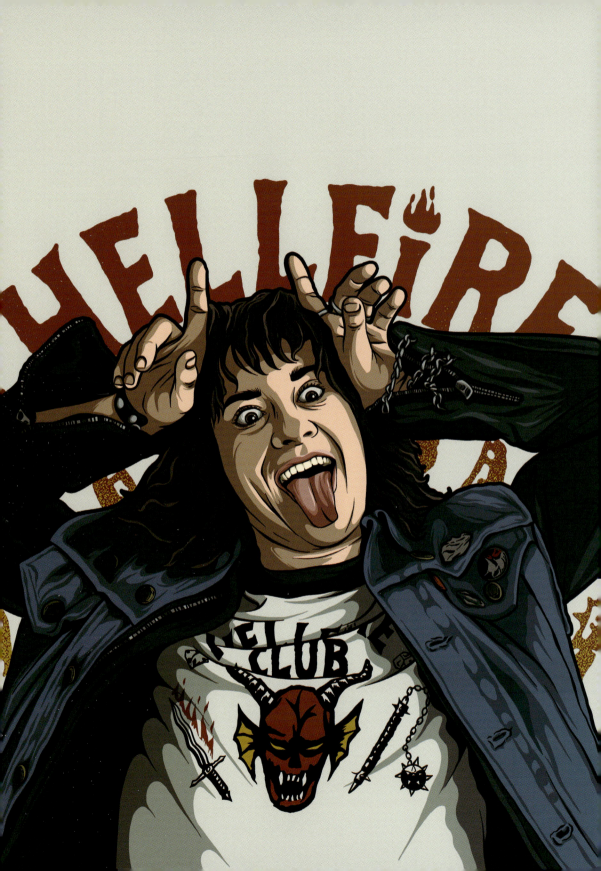

"THIS YEAR IS MY YEAR. I CAN FEEL IT"

"Este año es mi año. Puedo sentirlo"

- Eddie Munson -

Eddie Munson is a metalhead, non-conformist senior with an irresistible personality. He is loved and hated in equal parts. His rock aesthetic and tastes turn him into a character that captivates the audience from his very first appearance. Eddie enjoys playing D&D with his friends and has extensive knowledge of the game. He's the leader of the Hellfire Club, and has been looking forward to graduating from his student days for the last 2 years. He is confident that 1986 will be his year.

Eddie Munson es un estudiante de último curso, metalero, inconformista y con una personalidad arrolladora. Es odiado y amado a partes iguales, su estética rockera, y sus gustos hacen de este un personaje que desde su primera aparición, cautive al público. Eddie disfruta jugando a D&D con sus amigos y tiene un amplio conocimiento del juego. Es el líder del Hellfire Club, y desde hace 2 años está deseando graduarse para dejar atrás su etapa de estudiante, confiando en que 1986 será su año.

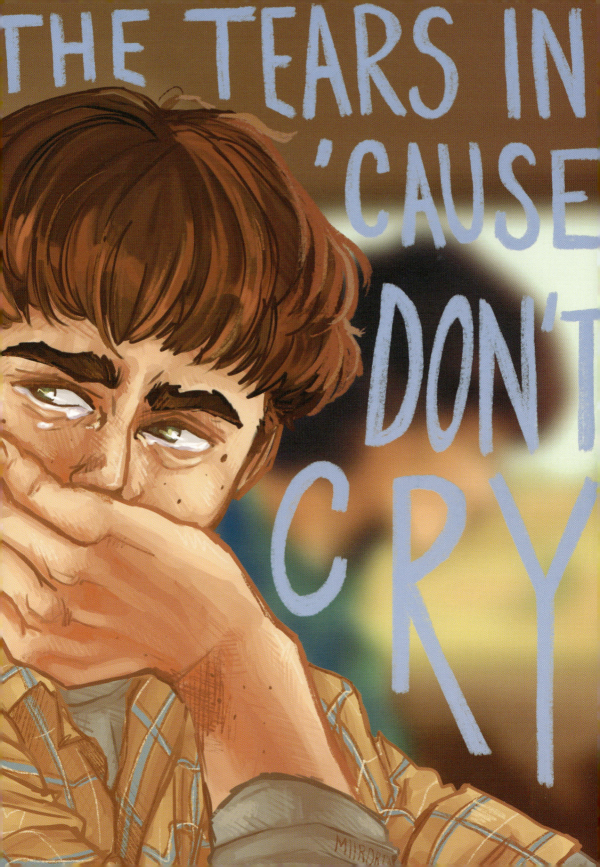

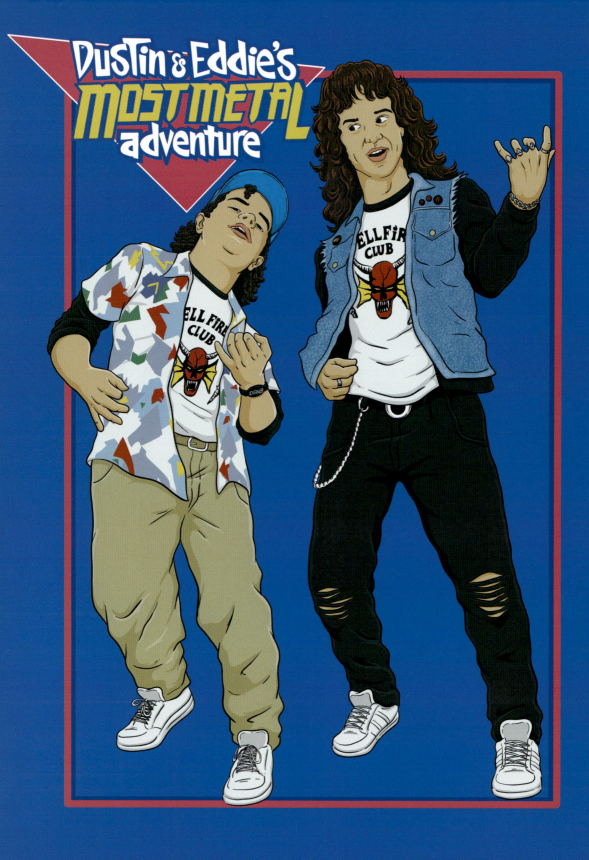

"HELLFIRE CLUB"

"El Club Fuego Infernal"

- Eddie Munson -

The Hellfire Club is a club where friends meet to play games of Dungeons & Dragons, a heroic fantasy role-playing game. Eddie Munson, an eccentric senior student and leader of the club, is in charge of animating and guiding his friends through a major campaign in his role as Dungeon Master. We also find Mike and Dustin in the club, who, thanks to Eddie, have managed to find their place in this new stage of their student lives.

"Hellfire Club" es un club donde se reúnen amigos para jugar partidas de "Dungeons & Dragons", un juego de rol y fantasía heroica. Eddie Munson, un excéntrico estudiante de último curso, y líder del club, es el encargado de dar vida y guiar a sus amigos hacia una gran campaña desempeñando el papel de Dungeon Master, donde también encontramos a Mike y Dustin, que gracias a Eddie han encontrado su sitio en esta nueva etapa de estudiantes.

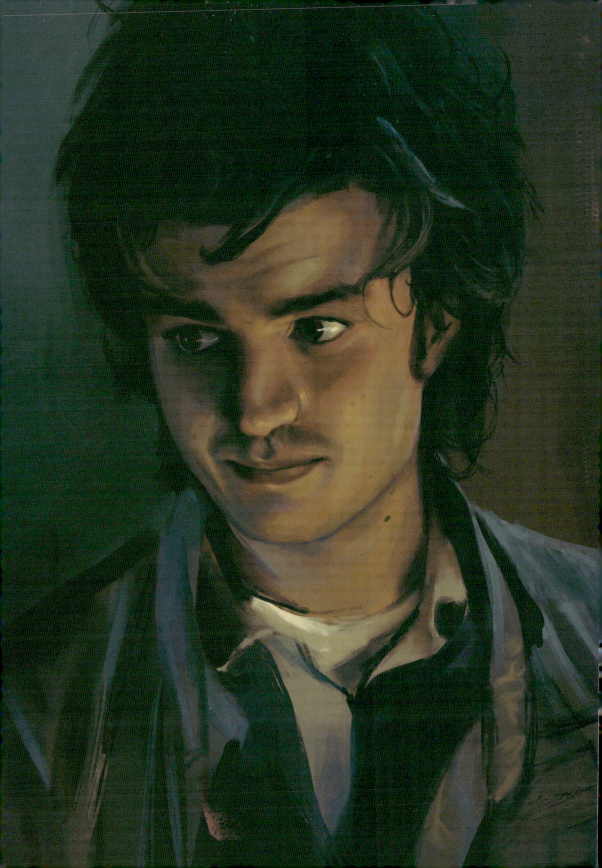

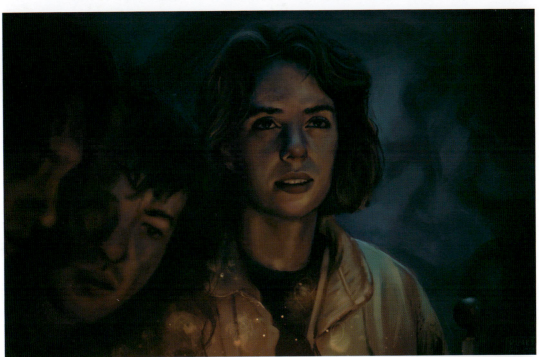

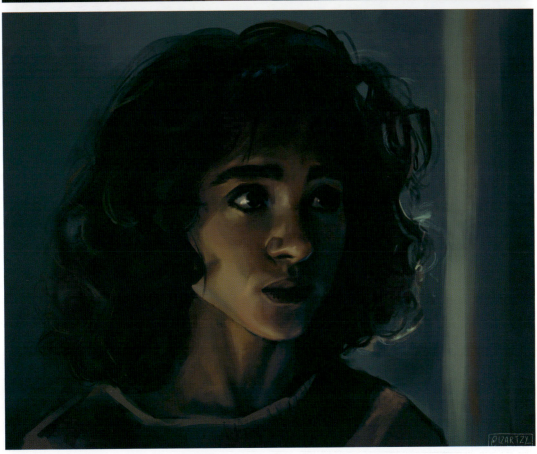

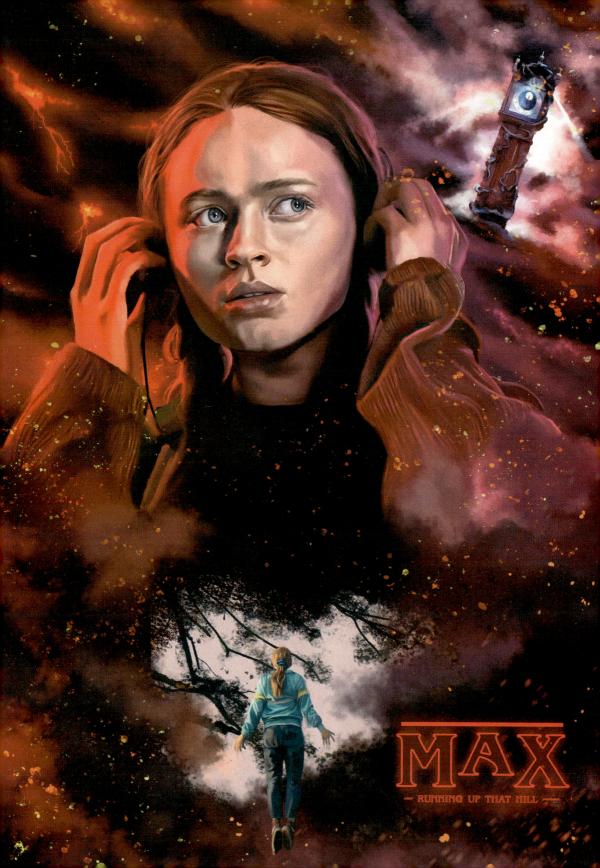

MAX

— RUNNING UP THAT HILL —

"I JUST SAW THAT GODDAMN CLOCK, SO... LOOKS LIKE I'M GONNA DIE TOMORROW"

"Acabo de ver este maldito reloj, así que... parece que voy a morir mañana"

- Max Mayfield -

'Running up that hill' is one of the most popular songs of this season. The singer and songwriter, Kate Bush, couldn't believe that one of her songs, written in 1985, had made it to number one on the most important charts in the world. It has had over 8,422,766 plays on iTunes and Spotify and counting.
Max could not have chosen a better song for his salvation.

"Running up that hill" es una de las canciones más populares de esta temporada, su intérprete y creadora Kate Bush, no daba crédito al ver como una de sus canciones, creada en 1985, se convirtió en número 1 de las listas de reproducción más importantes del mundo. Consiguiendo más de 8.422.766 reproducciones en iTunes y en Spotify, y que sigue sumando. Sin dudarlo, Max no podía escoger mejor canción para su salvación.

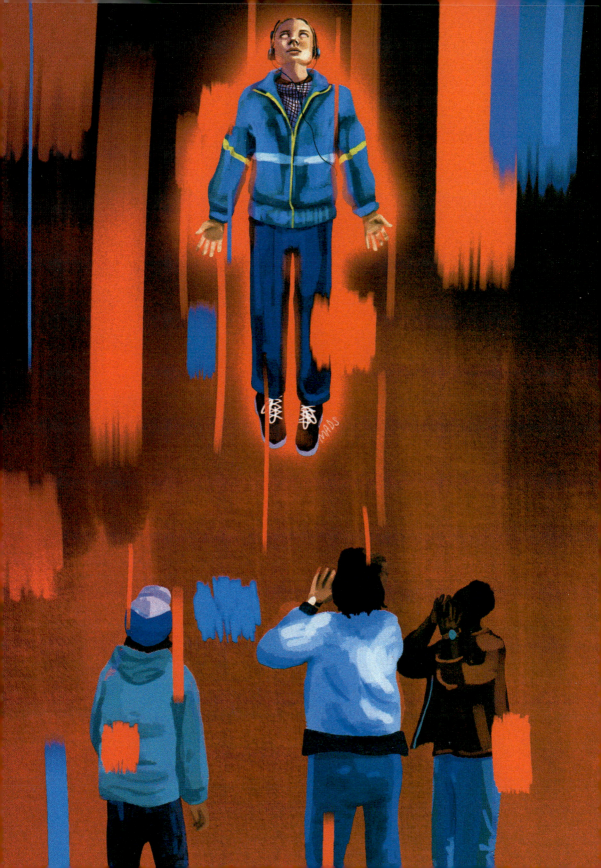

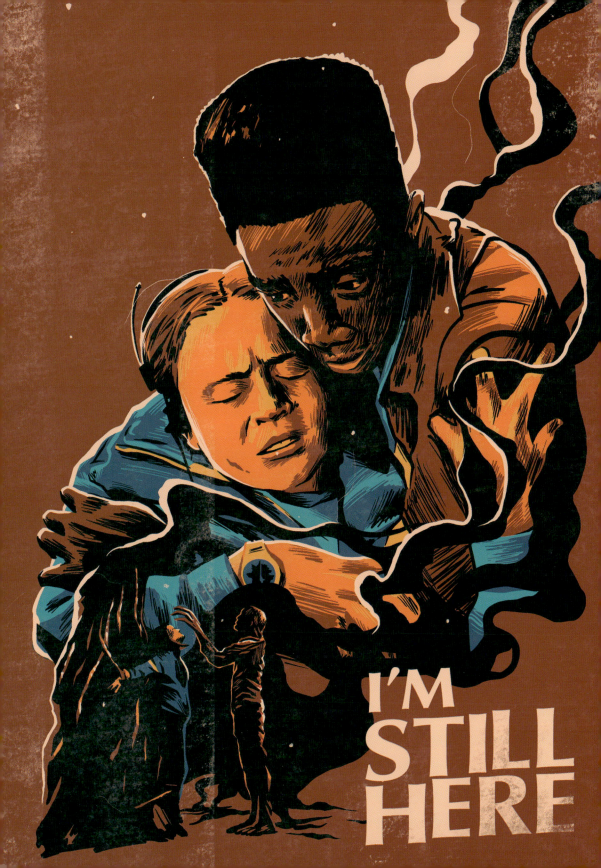

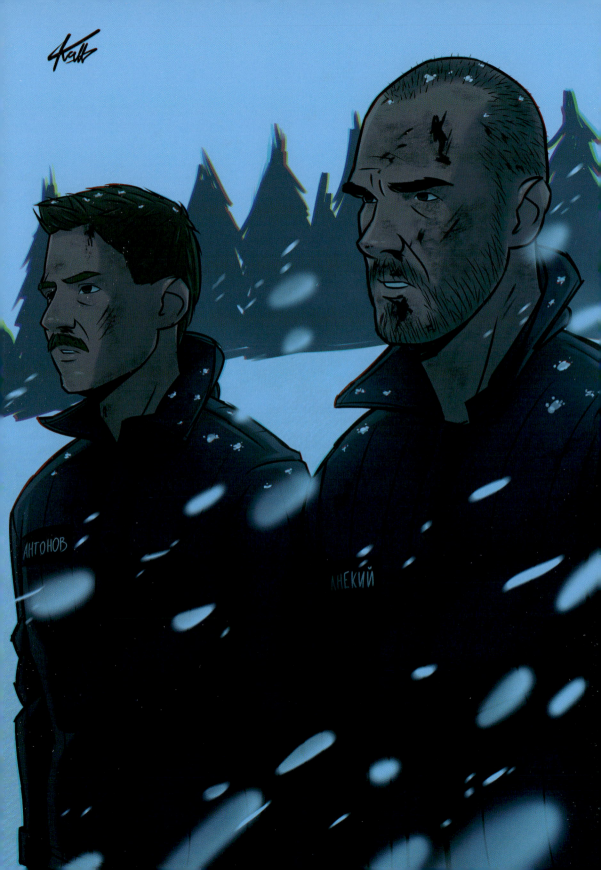

"YOUR FRIEND IS STUCK.
BUY YOU GIVE ME MONEY,
I MAKE HIM UNSTUCK"

"Tu amigo está atascado. Me das el dinero,
y lo hago despegar"
- Dimitri -

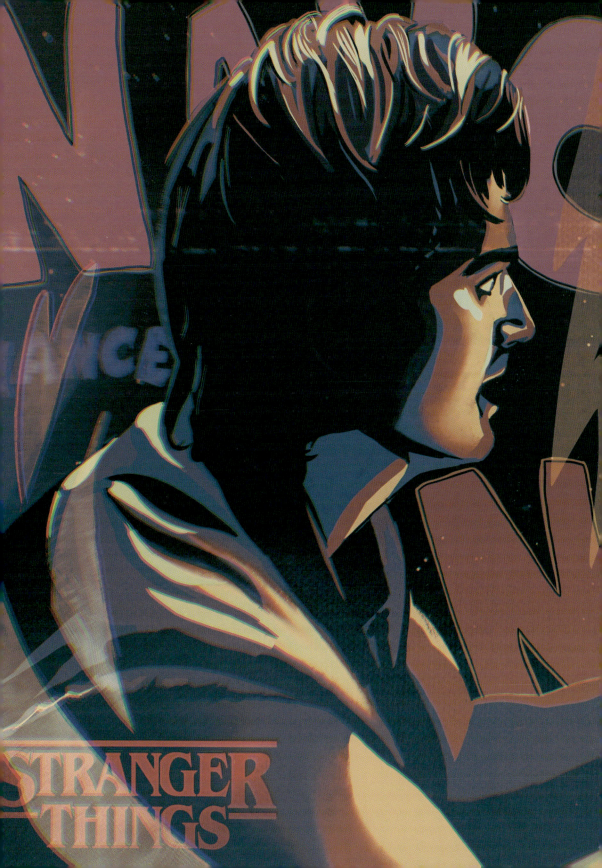

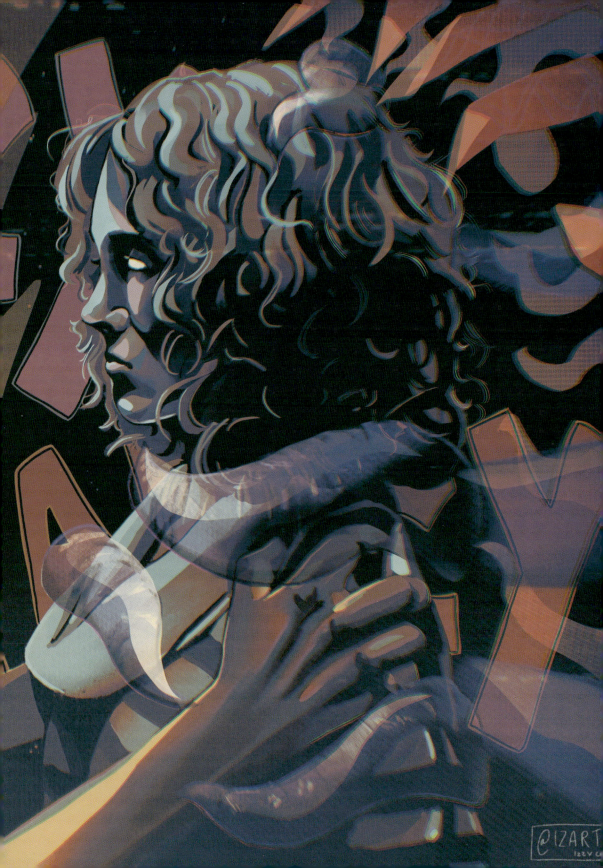

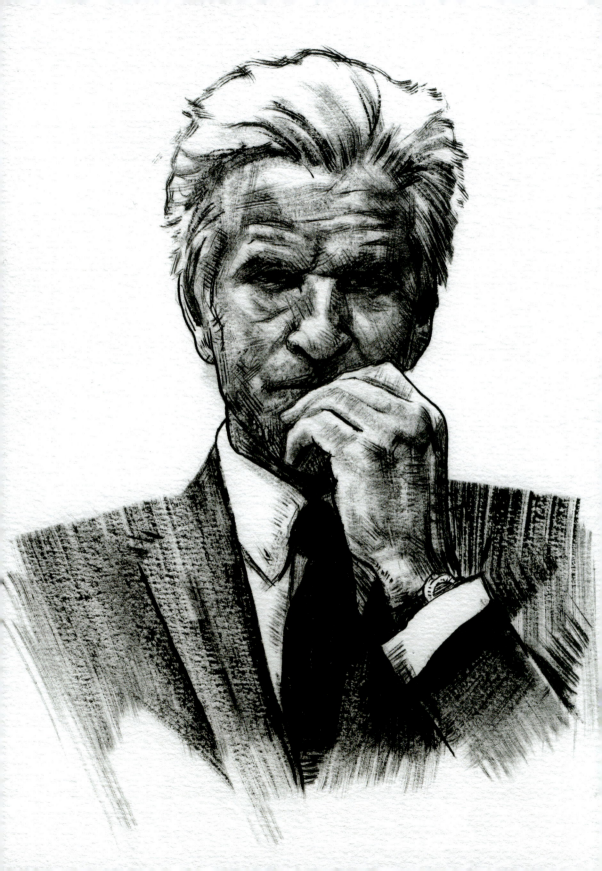

"THEY'RE LAUGHING. AT YOU. THEY THINK YOU'RE WEAK. SHOW THEM, ELEVEN"

"Se ríen. De ti. Creen que eres débil.
Demuéstraselo, Once"
- Dr. Brenner -

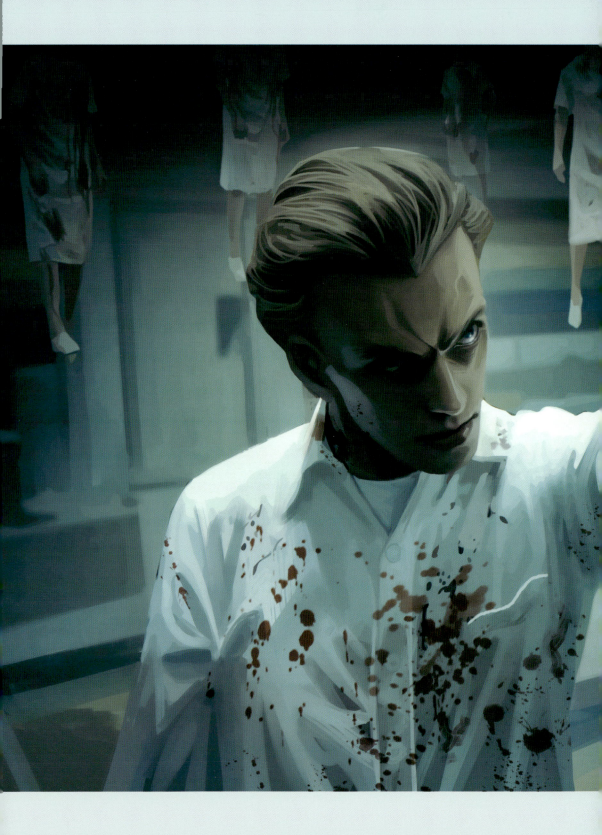

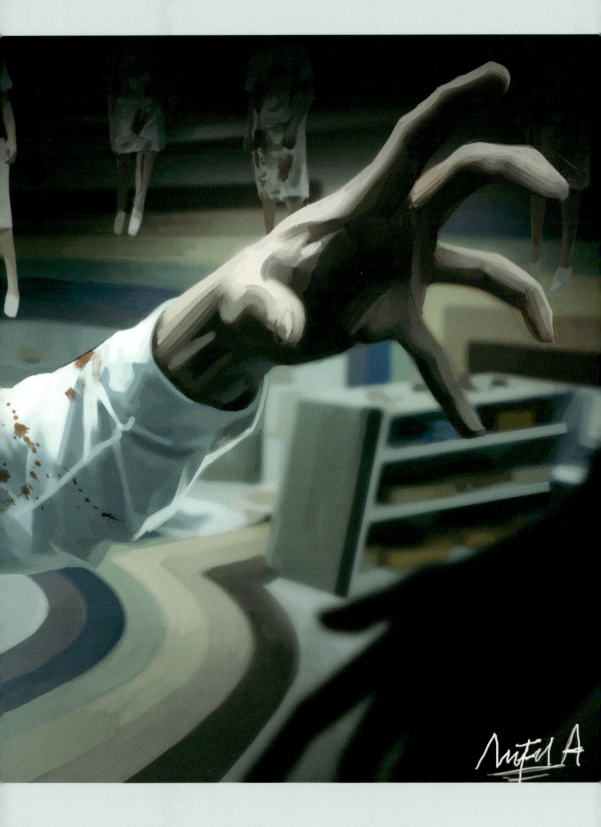

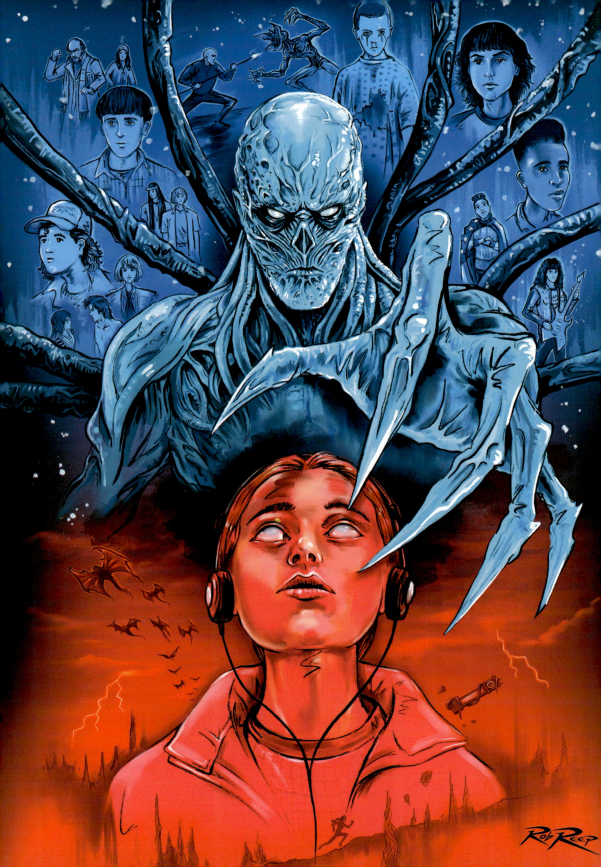

"YOU AND YOUR FRIENDS BELIEVE YOU HAVE WON.

DON'T YOU?

"Tú y tus amigos creéis que habéis ganado. ¿A que sí?"

- Vecna -

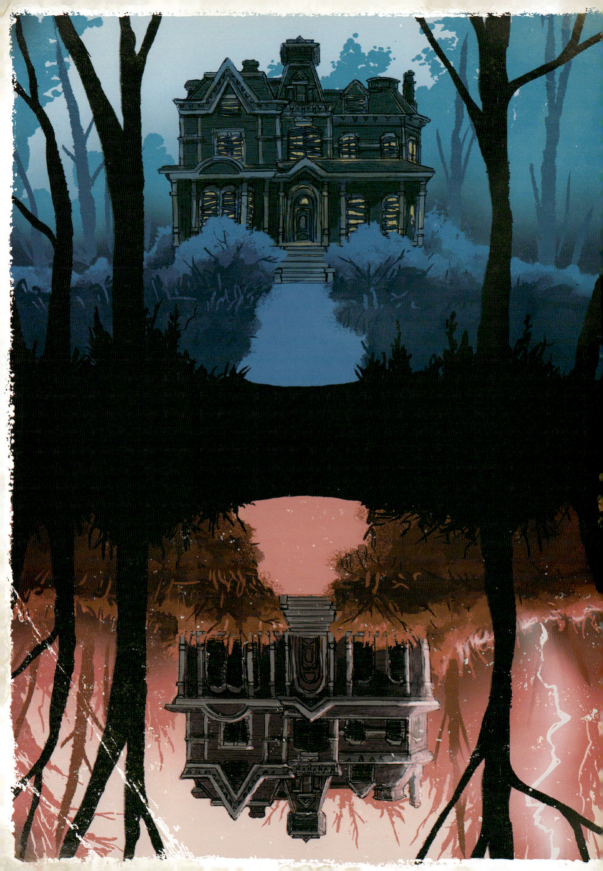

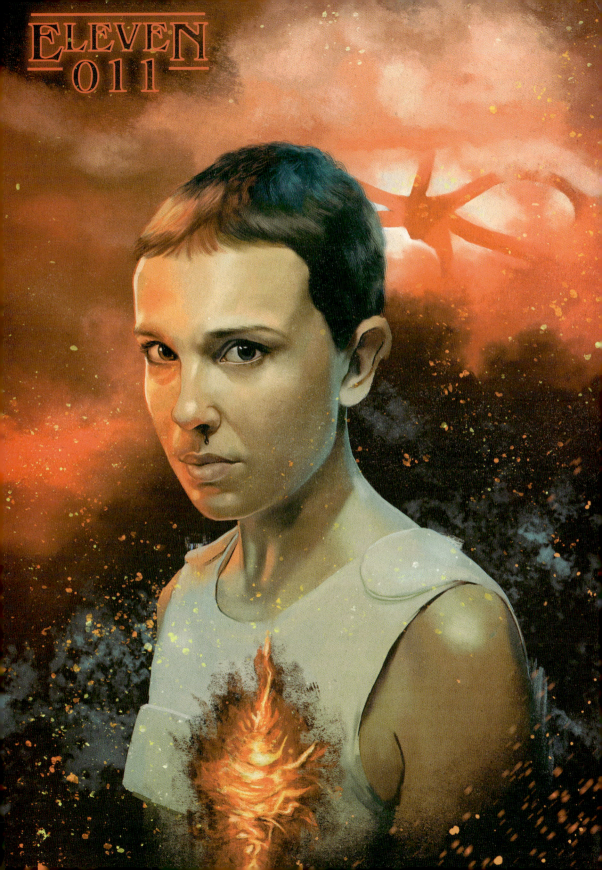

ELEVEN
011

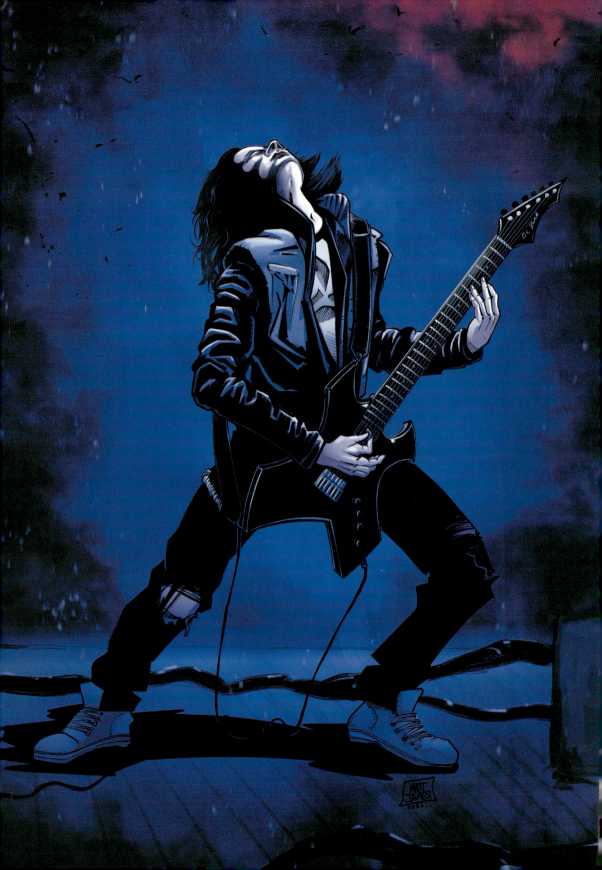

"CHRISSY, THIS IS FOR YOU"

"Chrissy, esta es para ti"

- Eddie Munson -

We highlight the song 'Master of Puppets', by the American thrash metal band Metallica, which Eddie uses to distract the demobats guarding Vecna's house.

Destacamos la canción "Master of Puppets", del grupo estadounidense de thrash metal Metallica, donde Eddie hace uso de ella para captar la atención de los demomurciélagos que custodian la casa de Vecna.

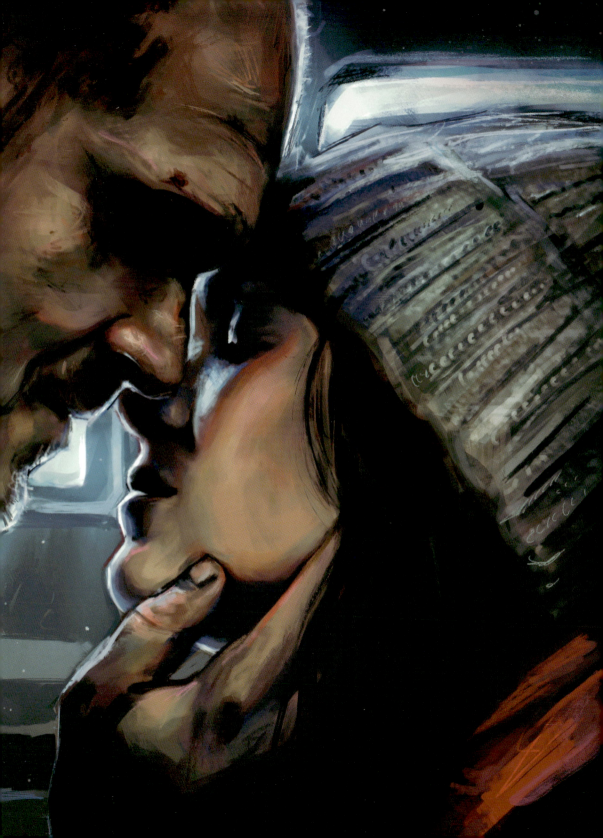

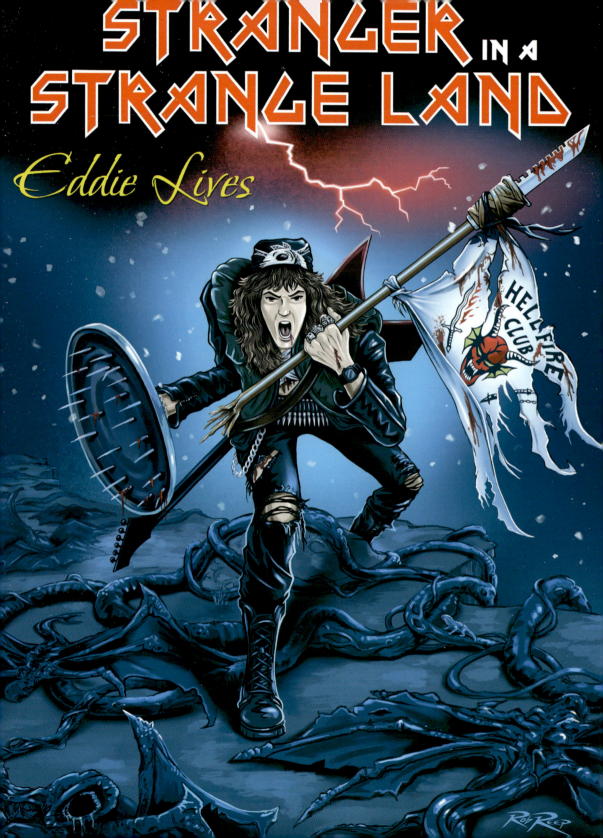

"I DIDN'T RUN AWAY THIS TIME, RIGHT?"

"Esta vez no he salido corriendo, ¿verdad?"

- Eddie Munson -

Artists info

ROB REEP
www.robreep.com
Instagram @robreepart
Facebook @RobReepArt
© pages 5, 51, 68, 130, 138.

JAMES OCONNELL
www.james-oconnell.com
Instagram @jamesp0p
Dribbble.com/jamesp0p
Twitter @jamesp0p
© page 6.

AMIEN JUUGO
www.behance.net/Amien15
Instagram @Amien15
Facebook @Amien15
© page 8.

DAVE PORTER
Instagram @daveporters_art
Facebook @daveportersart
© pages 10-11.

LADISLAS
www.ladislasdesign.com
Instagram @ladislas_c
Facebook @ladislasdesign
© page 12.

LIZA SHUMSKAYA
www.linktr.ee/Kino_maniac
Instagram @kino_maniac
© pages 14-15.

JOSEPH SHELTON
Instagram: @artofjosephshelton
Twitter: @artofjoseph
© pages 2-3, 16-17, 26-27, 52-53,
58-59, 106-107, 110, 142-143.

DANIELLA SJÖSTRAND
www.daniellasjostrand.myportfolio.com
Instagram @bwanalicious
© pages 18-19, 34, 46.

LIMKUK
www.artstation.com/limkuk
Instagram @limkuk
Facebook @LimkukMx
© pages 35, 105.

INGRID EV "INGA"
Instagram @ingridevart
© pages 20-21.

SAM GILBEY
www.samgilbeyillustrates.com
Instagram @samgilbey
Facebook @samgilbeyillustrates
Twitter @samgilbey
© pages 22, 46, 72.

MIKE FEEHAN
www.mikeseriously.tumblr.com
Instagram @mikeseriously
© page 24.

ALEJANDRO BARRIOS
www.behance.net/aartmoore
Instagram @aart.moore
Facebook @aartmoore98
© page 30.

JOSHUA BUDICH
www.joshuabudich.com
Instagram @jbudich
Twitter @jbudich
Facebook @jbudich
© page 32.

FREYA BETTS
www.freyabetts.co.uk
Instagram @freyabettsart
Facebook @freyabettsart
© pages 36, 38, 102.

PAUL MANN
www.paulmannartist.com
Instagram @paulmannart
Facebook @paulmannartist
© page 39.

TOM TRAGER
www.teepublic.com/user/tomtrager
Instagram @tomtrager
© page 40.

KRIS HILDERBRAND
www.krishilderbrand.wixsite.com
Instagram @art_thou_hilderbrand
© page 132.

VINCENT TRINIDAD
www.vincenttrinidadart.com
Instagram @vincenttrinidadart
Facebook @vptrinidad021
© pages 41, 54, 64.

EGOR
www.golopolosov.com
Instagram @egor_golopolosov
www.behance.net/egorg
© page 42.

NIKITA ABAKUMOV
www.displate.com/nabakumov
Instagram @n_abakumov_art
© page 45.

HAL HEFNER
www.halhefner.com
Instagram @halhefner
Facebook @halhefner
Twitter @halhefner
© pages 48-49.

DANIEL (VICKASH) BHAWANI
Instagram @sk8rdan
© pages 50, 78, 114.

TATA
www.tatakorenskaya.tumblr.com
Instagram @tatakorenskaya_art
© page 55.

GERMAN GONZALEZ
www.germangonzalez.studio
Instagram @_germangonzalez
© page 60.

NICKY DRAVEN
Instagram @nicky_draven_
© page 61.

KALLEB
Instagram @kalleb_dias
© page 122.

CRISTINA FRANCO RODA
www.menganitadecual.com
Instagram @MENGANITAdecual
© pages 118, 133.

KREG FRANCO
www.kregfranco.com
Instagram @kregfranco
Facebook @kregfrancoartcollection
Twitter @kregfranco
© pages 56, 76, 89, 126.

JASMINE DIMMOCK
www.jasminedimmock.wixsite.com/jasminej1577
Instagram @jasminej1577
© pages 62-63, 79.

SAM GREEN
www.linktr.ee/samgreenartist
Instagram @samgreenartist
© page 72.

MAXINE VEE
www.maxinevee.com
Instagram @artofmaxinevee
Facebook @artofmaxinevee
Twitter @artofmaxinevee
YouTube Maxine Vee
© page 66.

ZEROBRIANT
www.zerobriant.net
Instagram @zerobriant
Facebook @zerobriant
© pages 28, 74-75, 82-83.

VAN SAIYAN
www.vansaiyan.com
Instagram @van_saiyan
© pages 84, 90, 104.

JEF GREGORIO
Instagram @jefgregorart
© page 80.

ROON RISH
www.behance.net/RoonRish
Instagram @kunemor
© pages 88, 99, 101.

SHANNON TAYLOR
www.shannondtaylor.com
Instagram @magicmakerdreamweaver
© page 96.

RODRIGO SUAREZ
www.artstation.com/rodrigosuarez
Instagram @rodri_suarez__
Twitter @AboutRodrigoArt
© page 92.

LUKE MOLVER
www.lukemolver.com
Instagram @lukemolver
Facebook @lukemolverart
© pages 69, 93.

DIANA MALYSHEVSKA
Instagram @dana_malish
Twitter @dana_malish
© pages 94-95, 103.

MATTHEW THOMPSON
www.etsy.com/shop/thompsonartstore
Instagram @thompsonart
© pages 108, 121.

IZZY
Instagram @izartzy_
© pages 116-117, 124-125,136-137.

MADDY SALGADO
www.elestras.com
Instagram @elestras
Twitter @elestras
© page 120.

MATT JAMES
www.snakebitartstudio.com
Instagram @snakebitartstudio
© page 134.

NAOFARO
Instagram @naofaro
© pages 128-129.

PAIGE MANLEY
www.paigemanley.artstation.com
Instagram @miiroren
© pages 112-113.